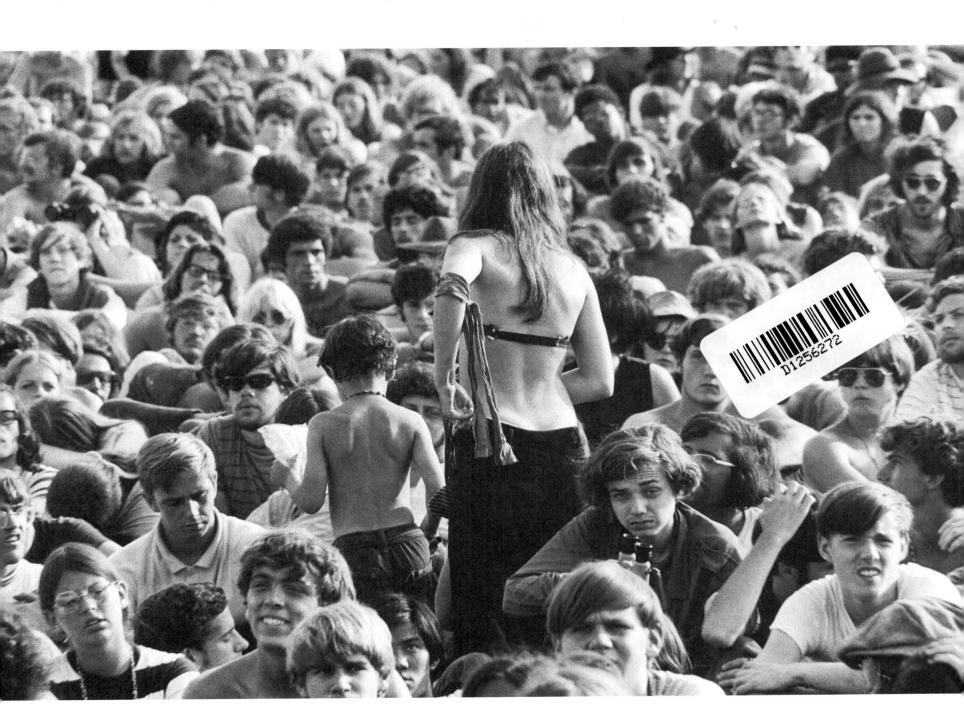

woodstock 1969

woodstock 1969

The Lasting Impact of the Counterculture

photographs by Jason Lauré

Text by Ettagale Blauer and Jason Lauré
Foreword by Dennis Elsas

10 9 8 7 6 5 4 3 2 1

Library of Congress Cataloging-in-Publication Data is available on file.

Cover design by Rain Saukas
Interior Design and Layout by Tania Bester
Scans by Pam McKenzie, ORMS, Cape Town
Scans by Bob Kapoor Duggal, New York

Print ISBN: 978-1-5107-3073-1
Ebook ISBN: 978-1-5107-3074-8

Printed in China

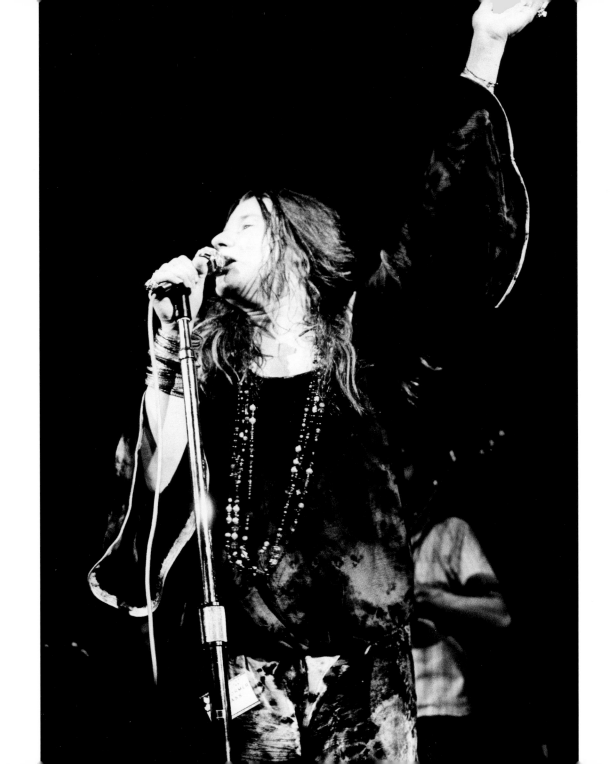

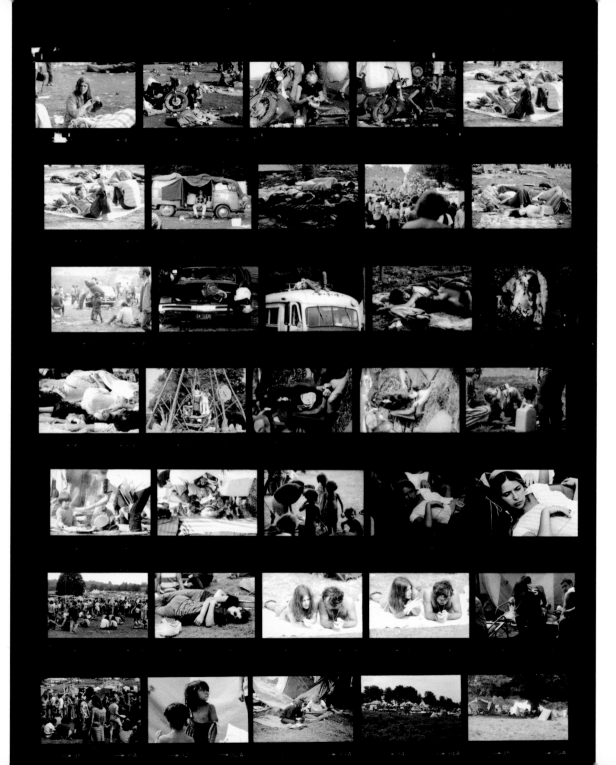

CONTENTS

Foreword by Dennis Elsas

The "Woodstock Music and Art Fair"" is often seen as a cultural touchstone for a generation that came of age in the 1960s and '70s. For many of us it represents a magical, almost mythical, moment in time (August 15–17, 1969) when rock music presented in a pastoral setting of a half a million people could unite a community in love, peace, and freedom. Nearly fifty years later, despite countless essays, books, and documentaries to explore it, the story may still be a bit difficult to appreciate for those of us that weren't actually there.

I was traveling through Europe that summer, a recently graduated college student, who first learned about the festival when my father sent me a series of newspaper clippings in the mail describing the event. "Hippies Mired in a Sea of Mud" was one of them and in that pre-digital age of communication it was only a few weeks later when I arrived home in New York that I began to comprehend the scope of what had happened. It wouldn't be until the following spring of 1970, upon the release of the documentary film and accompanying three record set chronicling the Festival, that we could really vicariously begin to celebrate the enormity of those three days.

In the years that have followed, my fascination with the Festival has continued to grow. As a NYC rock radio host since July 1971, I've shared my observations through countless anniversaries and opportunities

on-the-air in presenting the music and interviewing the participants throughout the decades. My first visit to the festival site (which is interestingly not in Woodstock, but actually fifty miles away in Bethel, New York) was in the summer of 1979. I was dating my future wife and she had actually been at the Festival, since her family owned a small summer home just down the road. Ultimately, I would become involved in the creation of the Museum at Bethel Woods, just next to the festival site, and my voice can be heard narrating several of the exhibits there that tell the story.

Jason Lauré's photographs and co-author Ettagale Blauer's commentary present an approach to these historic events which is unique and highly personal. The photos are beautiful and vivid, providing an eyewitness account of this remarkable moment in time. The festival and the era clearly made an impact on Jason and the book offers us the opportunity to share his experience.

How I Got to Woodstock

For me, the road to Woodstock began in San Francisco during the Summer of Love of 1967. When I arrived there by train, from a sheep farm in Washington state, midway between Portland and Seattle, where I was raised by my grandmother, I thought I had arrived on another planet. Haight-Ashbury was so different from anything I had experienced. It was a huge test lab of the future, people leaving behind the ideas they had been brought up with.

It was like a twenty-four/seven street party. There were no normal shops. There were shops run by charities and churches. The Digger's shops provided free clothes, the medical clinics offered free medical care for the teenagers who were taking drugs and having bad trips. The Hamilton Methodist Church and other churches were handing out food. Young people were getting all their food from soup kitchens. No one seemed to work. They hung out at Golden Gate Park, smoking and getting high.

I bought a cheap Exakta camera and began photographing my friends. Right away, I had a style, photographing people. I would go out and photograph every day, then I would have the film processed and have contact sheets made. I didn't realize it but that is what professional photographers do. Then I would choose which images to have printed up. I was never an amateur photographer.

My path was really set after I took LSD. I was high for three days and after that, everything changed. It was one of the most significant things in my life. I thought I could be doing photography, seriously. A week later I was back on the train, heading to New York to take a photography course.

I heard about the Woodstock Festival from Jenny, my girlfriend in San Francisco. We had stayed in touch after I left there. The people who produced Woodstock thought it would be like the June 1967 Monterey Pop festival where about 50,000 people turned up, most from the local area. They didn't count on the power of the underground press which is how many young people got their news.

Woodstock had a similar feeling to the Summer of Love, just uninhibited folks, doing what they wanted, being happy. It helped that most of them were smoking marijuana or taking LSD. Their relaxed mood made it easy for me to move around and be unnoticed. I was also in tune with the people and the music. What made Woodstock much more than just a music concert is that people look at that sense of happiness and want to capture it somehow in their lives. Woodstock was filled with people who were at the crossroads of their lives. People were getting married, people were deciding whether or not to go to college, people were going into the army. The very real possibility of being drafted and sent off to Vietnam was hanging in the air.

I went to Woodstock with a camera bag. That was my only luggage. Two Nikon cameras that I still have, one for color, one for black/white. I had two lenses, 80-200 for the stage work, 35-50 mm for the communal

work, and twenty rolls of film. I brought Tungsten film to shoot at night. I had never used it before but someone had told me that it was the best color film to use for the night shoots. I had a photo pass from the Woodstock concert folks and could move back and forth from the stage area to the camping area. I spent my days photographing the life of the festival goers and the musicians on stage at night.

Photographing the music, I knew the music. I could anticipate what the musicians were going to do. You can see that in the photos of Sly when he raises his arms and the fringes on his jacket go flying. I could capture that in a still photo because I felt the rhythm.

On Monday morning, when I was standing on the hill looking down, on the crowd, way off in the distance, I could see Jimi Hendrix singing his memorable rendition of the national anthem. I took my last photo of the crowd on the hill and then met up with Mike, the guy I came up with, and we drove back to the city. This was history, not just a rock concert.

—Jason Lauré

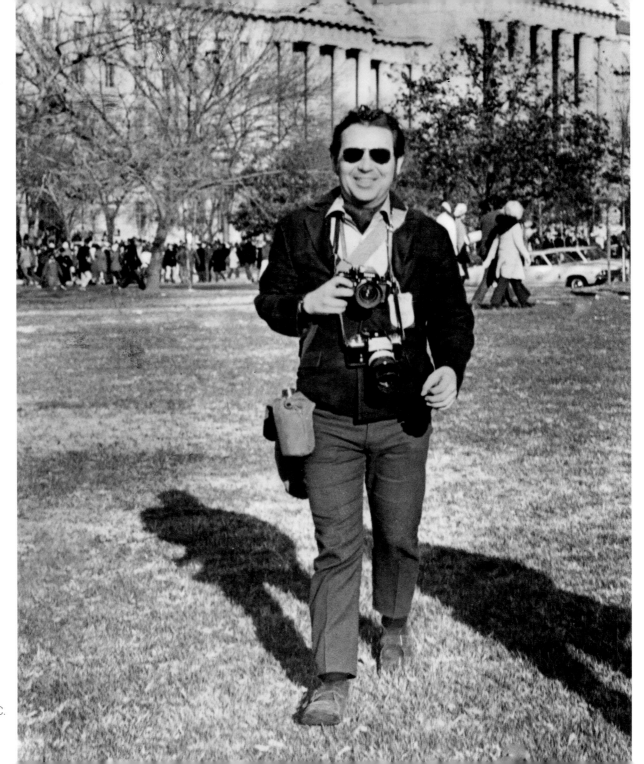

Jason Lauré at the anti-war
moratorium in Washington, DC.
© 1969 by Mark Vargas

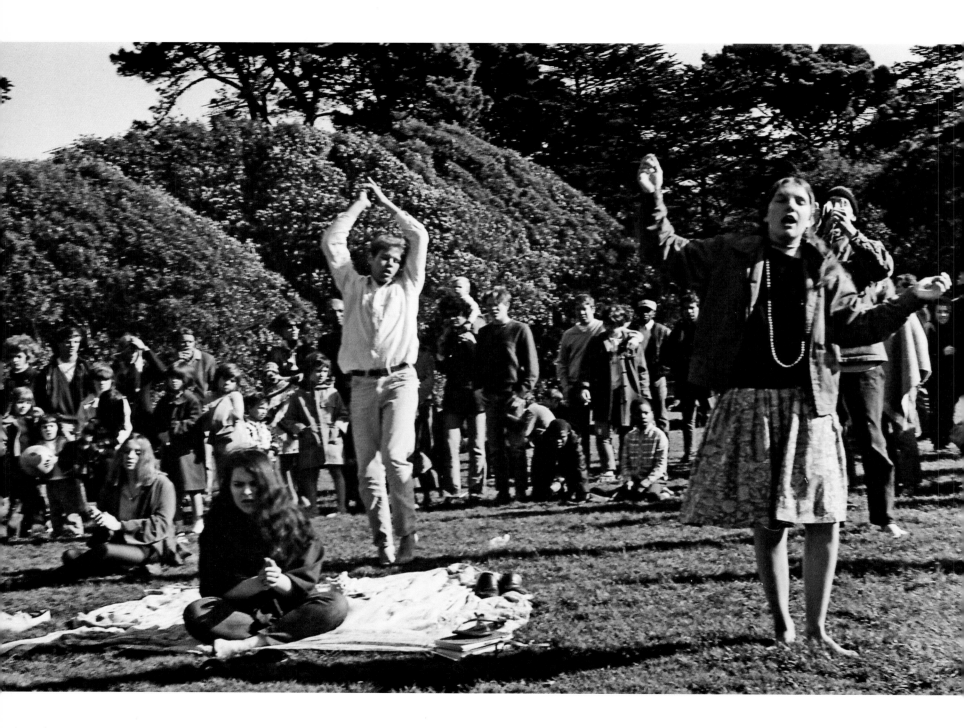

Summer of Love

Erasing Boundaries

Clear, crisp lines between life and art, work and play, the rigid divisions between men's jobs and women's work, were all in play during the 1960s, culminating, at least in the popular media, in 1967, in the Summer of Love.

Historic changes don't really fit neatly into three-month time frames. They don't start on June 1 and end on August 31, any more than the temperature and rainfall obey the dates on the calendar. Life is much messier than that, and like the much-disobeyed basic stricture of the childhood classroom, the so-called Flower Children of the Sixties generation always colored outside the lines.

The buttoned-down mind gave way to the collarless Nehru jacket, the free-form dashiki, and the flowing muumuu. It wasn't only bras that were burned. Corsets went too, though some women actually feared their spines might not support them without the firm grip of panty girdles.

The Sixties generation didn't invent the concept of mind-altering drugs, but the drug of choice has varied through the ages. Opium in Victorian England, alcohol widely used in the American Roaring Twenties, peyote, snuff, absinthe, single-malt whiskey, 3.2 beer (low-alcohol beer introduced after Prohibition), coffee, tea, and, of course, marijuana—humans have always sought something to change their moods, ease pain, lift spirits, and open their minds to a higher level of consciousness.

At the same time, governments and religious-based societies have sought to discourage and continually ban virtually all of these substances, while enjoying the taxes they generated. The US government, above all, has proven to be so two-faced in its approach to mind-altering substances it simultaneously warns smokers about the likelihood of dying from cigarette smoking whilst taxing tobacco products and allowing them to be sold openly, even in pharmacies.

Beyond all else, though, it was music that defined each generation, as well as the changing ways in which it could be enjoyed. From the private, at-home chamber music concert to the concert hall, from bands traveling with vaudeville shows to small orchestras accompanying silent movies, music was part of the mood of each age. Scott Joplin's ragtime was as scandalous at the turn of the last century as Elvis Presley was in the 1950s and the Beatles in the early 1960s. Each successive type of music or new singer seems designed to outrage and dismay the listeners' parents.

Those were the scene setters for the Age of Aquarius, the adherents of psychedelic music, art, and drugs.

The Sixties generation came of age at a time when middle-class comfort and security gave younger people the freedom to revolt, to protest, and to experiment, and they did so against the background of an assured safety net. Dropping out, whether from college or a job, or just for a drug trip, wasn't the end of the

road as it had been for the down-and-out folks of the Depression-era 1930s. Those souls were truly lost, truly homeless, truly impoverished. The hippies, as they came to be called, had tremendous resources to absorb their voluntary falls from society. The economy was flourishing, jobs were available to those who wanted them, and higher education was affordable to most.

The true threats came from the looming war in Vietnam, never really declared but a monster "police action" that came to claim some 57,000 lives, and symbolized by the soldiers coming home in body bags and the omnipresent threat of the universal male draft. These were the real causes that provided the glue for the diffuse angst and yearnings of the teens and young adults who were searching for more meaning in their lives than a steady paycheck, three meals a day, and a solid roof over their heads.

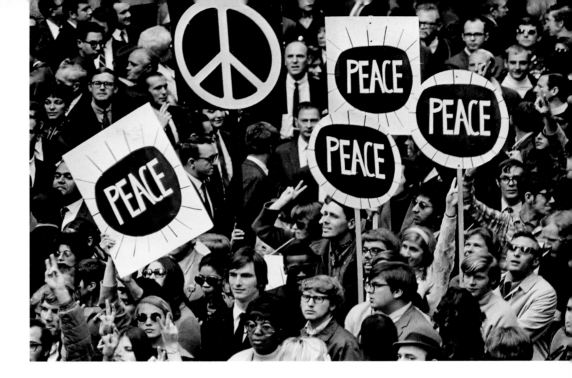

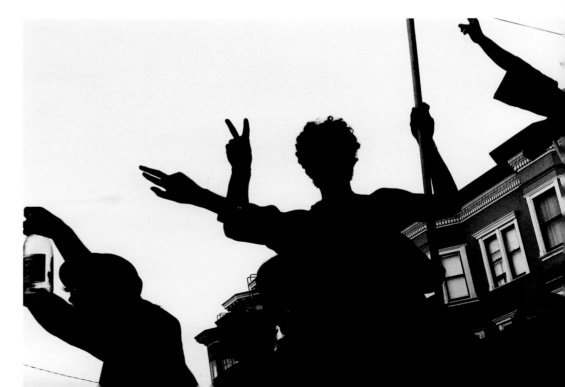

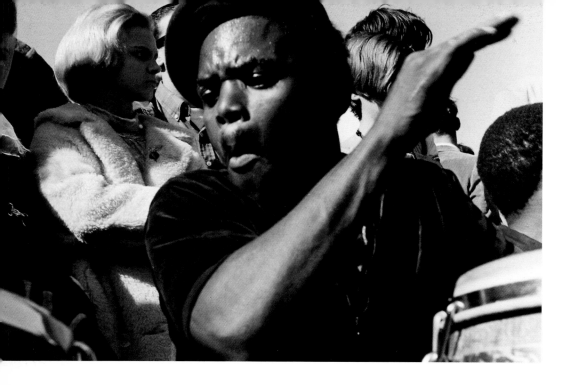

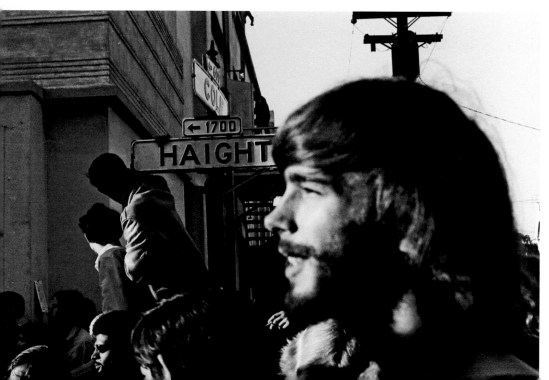

Finding causes greater than themselves—and most certainly greater than their parents' desire for security—led to the first large-scale protests. Fueled by mind-altering drugs, young people began a journey to a "counterculture," an absolute revolt against the culture they were raised in. The reverberations of that revolution continue to the present day, greatly transformed and channeled into the creation of mind-altering machines: the personal computer, the cell phone, the laptop, the smart phone, computer tablets, and all their miniaturized offshoots.

While the Sixties generation had to rely on word of mouth to get their messages out, today's youth can assemble a crowd in a flash for the most exalted causes—protests against dictators, school shootings, and political figures—and the most mundane—summoning a crowd to occupy a space for the sheer joy of exercising the power to disrupt.

Though the dissemination of the message may have taken longer, the commercial media helped enormously, even while disparaging those who marched for their causes and made their art.

It was the art that captured everyone with access to a weekly news magazine, a billboard, or a poster. A wave of art genres swept over the nation: pop art, op art, psychedelic art. Each flamed brightly, albeit briefly, across the firmament as the short attention span of media consumers moved from one to the next. But psychedelic art would prove to be the most long-lasting. And, like much of the fashion and fads of the Sixties, this art comes back periodically, appealing afresh to a new generation that hasn't experienced the tie-dye clothes, long hair, and colorful graphic art of the era. If you haven't seen it before, it's new to you.

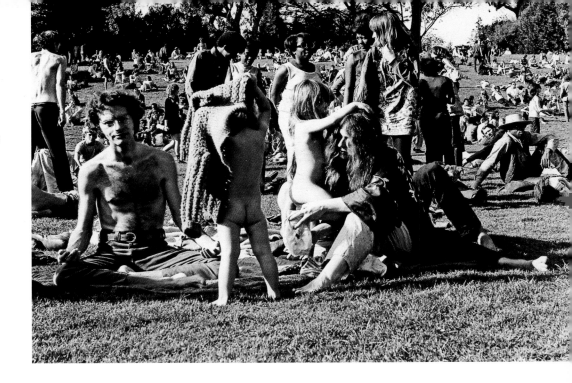

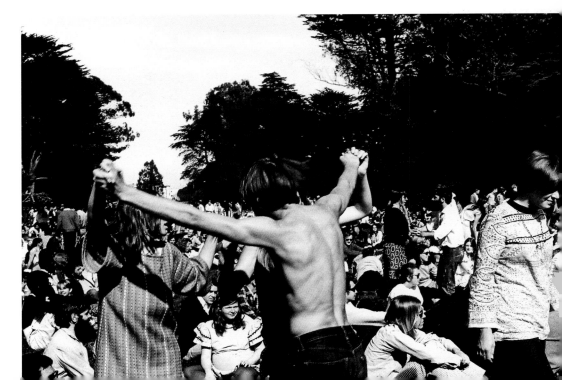

Impact of LSD

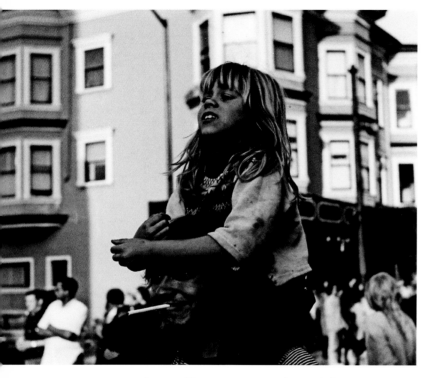

Borrowing selectively from Eastern religions and cultures, psychedelic art was the visible expression of mind-altering drugs. It enabled the creators of the art to share their visions from the hallucinations generated by the drugs. But the fact that it was viewed by those who were not high meant the art had to be appreciated just for its visual appeal and this it did very well. The exuberance of Sixties' culture was perfectly encapsulated in psychedelic art. With its comic-book colors, flowing curves, and outlined letters oozing across the surfaces, the imagery of psychedelic art took its inspiration and enthusiasm from the generation creating it.

It is no exaggeration to say that the whole movement toward a counterculture would not have happened without LSD and marijuana. Two pivotal figures contributed mightily to the creation and dissemination of LSD. Owsley Stanley, known to everyone in the counter-culture community as Owsley, was a chemist with a wide range of talents and interests. He worked closely with musicians while, at the same time, perfecting the mass production of LSD. He is said to have produced more than a million doses between 1965 and 1967, and was the supplier to most of the well-known bands of the Sixties. The US government experimented with LSD as a kind of "truth serum," but the results were so unpredictable that they gave it up entirely. It is now classified as a Class One narcotic with no medicinal benefits and is illegal in the US.

Timothy Leary, a psychologist, was more widely known to the general public for promoting the use of LSD in treating mental illness. At Harvard University, one of the bastions of upright American education and society, he conducted experiments that ultimately saw him fired, and eventually frequently convicted and incarcerated for his efforts. Up until 1968, the use of LSD was legal.

Though LSD enabled the mind to float freely, it was the invention of the birth control pill that enabled women to enjoy the freedom expressed by proponents of the counterculture. For the first time in the history of civilization, women were able to control their reproduction, to engage in sex without the act leading to pregnancy. Though the pill was not without its own side effects and consequences, the freedom from unwanted pregnancies was the true liberation movement for women. "Free love" was now truly free for both men and women.

So the seeds were sown for the Summer of Love in 1967, a coming together of young people seeking an endless summer of music in a city that seemed to exemplify their attitudes. San Francisco, like many seaports, was more liberal than the inland towns nearby, and its Haight-Ashbury neighborhood provided the perfect small-scale, urban environment to play host to the peaceful invasion that year.

The Summer of Love rode into San Francisco at a moment of perfect harmony. Everything you needed was freely available. It was possible, for a brief moment in history, to play at life with absolutely no responsibility for supporting that life.

For the teens and their slightly older cohorts, "life" was another word for getting away from anything that reeked of adulthood; being blissed out on LSD while listening to free concerts in Golden Gate Park, and not having a care about where the next meal or bed would come from. This was the essence of the Summer

of Love. Who could deny the charm of listening to the Grateful Dead and Jefferson Airplane in the balmy open air, sprawled out on blankets in the park? In June 1967, the Monterey Pop Music Festival introduced Jimi Hendrix and Janis Joplin to the world.

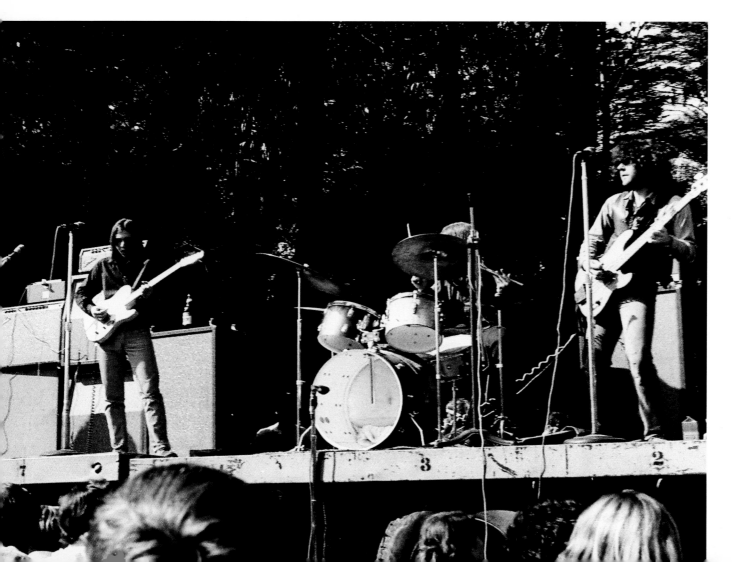

Timothy Leary, the pied piper of LSD, famously advised anyone who would listen to "Tune in, turn on and drop out," and at the intersection of Haight and Ashbury Streets, they did just that. They wore flowers in their hair and charmed the police by pressing flowers on them as well, oozing love and goodness. And largely, the police left them alone, at least

until the numbers became overwhelming. It is estimated that at the height of the movement, the Haight was the temporary home of some 75,000 free spirits.

It was just an interval, as it turned out, before reality struck. Someone had to earn money to buy food, someone had to cook that food, someone had to provide shelter for the night. Doctors had to staff the free clinics, giving their valuable expertise to the many injured, overdosed people who flooded in.

Whoever coined the phrase "Don't trust anyone over thirty" clearly didn't plan to live past that distant monument of antiquity. The city also became a magnet for young runaways who were trying to escape unhappy, perhaps abusive homes, who wound up being easy marks for predators, eager to take advantage of all that trust and free love. Life on the streets quickly lost its appeal. The difficulty of trying to live without any material resources met the chill of the San Francisco autumn. The Summer of Love was well-named—like the summer sun, it shone briefly and then seemed to disappear from view.

But the summer generated its own future, suggesting that there was a new way of life for many of the young people of that generation. Perhaps they couldn't live on the streets, but they could forge new paths, diverging from the comfortable, 9-to-5 world of their parents. Many moved to areas that became known as New Age communities, such as Taos, New Mexico. Others went abroad, where they either found or created communities that were more open to their lifestyles. Essaouira, a charming town on the Atlantic coastline of Morocco, became a favored destination, a place where life was less expensive, clothing styles were more conducive to the loose styles favored by the hippies, and hashish was readily available.

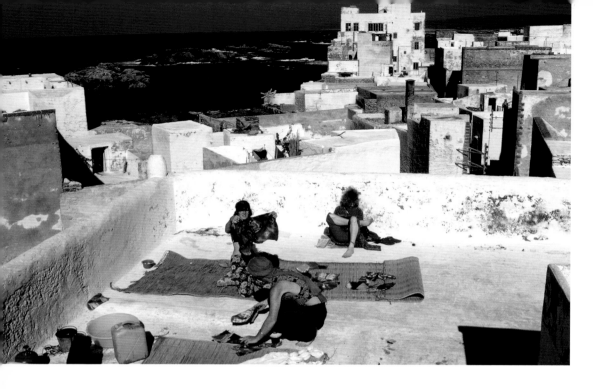

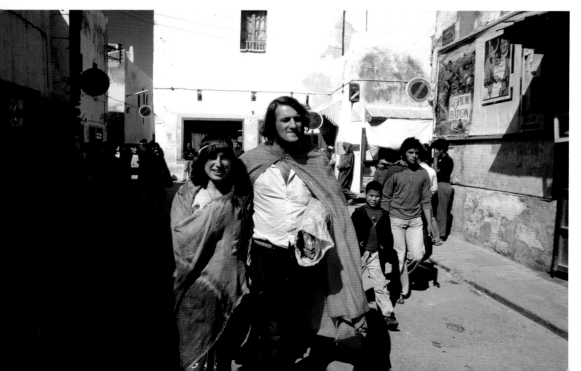

Essaouira, a charming, whitewashed town on the southwest Atlantic coast of Morocco, became home to a community of expat Americans and Canadians. They lived by making tie-dyed clothing on the roof of their commune and selling it to tourists. The brilliant sunshine added to the psychedelic colors and patterns. Morocco, in North Africa, was the perfect combination of a low-cost place to live that was both safe and exotic.

Be-Ins in Central Park

Meanwhile on the East Coast of the United States, it was the time of Be-Ins, large gatherings of young people with little more on their minds than to be with their own kind. In New York City's Central Park these events attracted hundreds of thousands of participants and were largely peaceful events, with teens dressed in outfits that were more costume than clothing. Those outfits, combined with long hair on both men and women and lots of flowers, served notice that these crowds were determined to "live and let live." The park's Sheep Meadow, soon to become well known as the setting for massively attended concerts, both classical and pop, served these events well and showed that enormous gatherings of people could be held peacefully in the heart of the city.

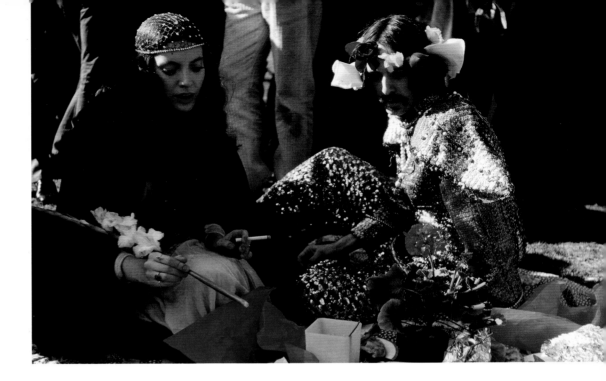

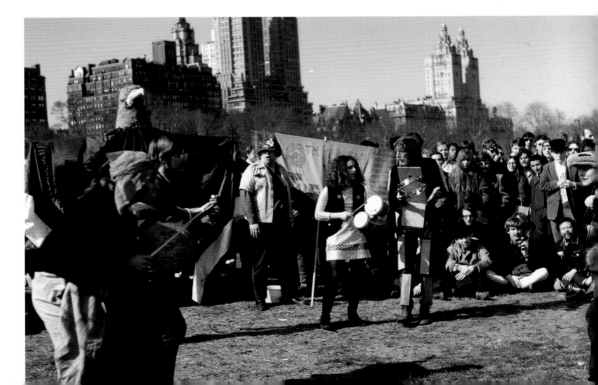

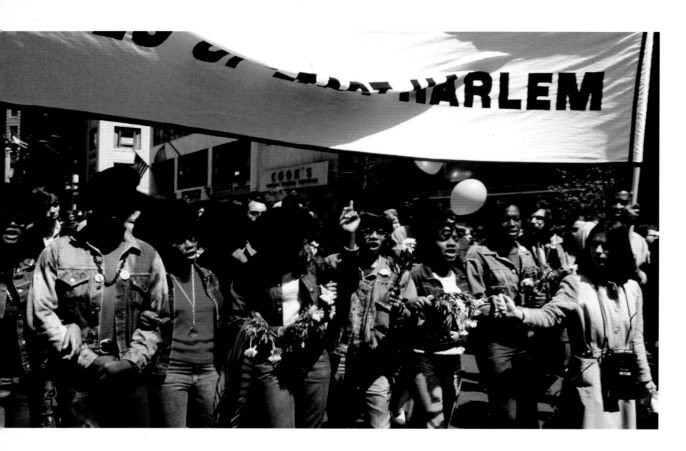

At the same time that young Americans were demonstrating against the war and the draft, young black men and women were struggling against inequality and a police system that used excessive force when dealing with them. The Black Panther Party, founded in October 1966, startled white Americans with its aggressive stance, black power salutes, distinctive black berets, and open display of guns. Though men such as co-founders Huey Newton and Bobby Seale were the principal figures putting forth the Black Panthers' message, women quickly became the majority of its members.

The women of the Black Panthers directed causes that spoke to their needs, including the Free Breakfast for School Children Program, Liberation Schools, and the People's Free Medical Centers. They worked as hard as their white sisters to break through gender stereotypes.

Jason says, "During the months that I spent in San Francisco in 1967 and 1968, I saw the powerful impact LSD had on people. It wasn't always pretty. Bad trips could leave someone's mind altered forever. It took a long time before I was ready to embark on my own life-altering LSD experience. Guided by my girlfriend Jeanne and other responsible, educated friends, I took LSD at dawn, at beautiful Muir Beach. At first, nothing seemed to happen. Then, about three-quarters of an hour after I took the little pill, the visions began.

Purple skies, orange seas, I remember most of it; it went on for three days and it was amazing. Lewis Carroll certainly got it right when he had Alice say, "One pill makes you larger, one pill makes you small." Grace Slick used the lines in her song "White Rabbit," freely adapting the mind-altering visions created by LSD. The drug heightened my senses beyond description. That was one of the most important, earth-shaking experiences of my life. It was so pretty, this little pill that could make you see things that you had never dreamed of before. It was perfect, and I never did it again. I didn't have to. The visions created a direction I've followed my entire life."

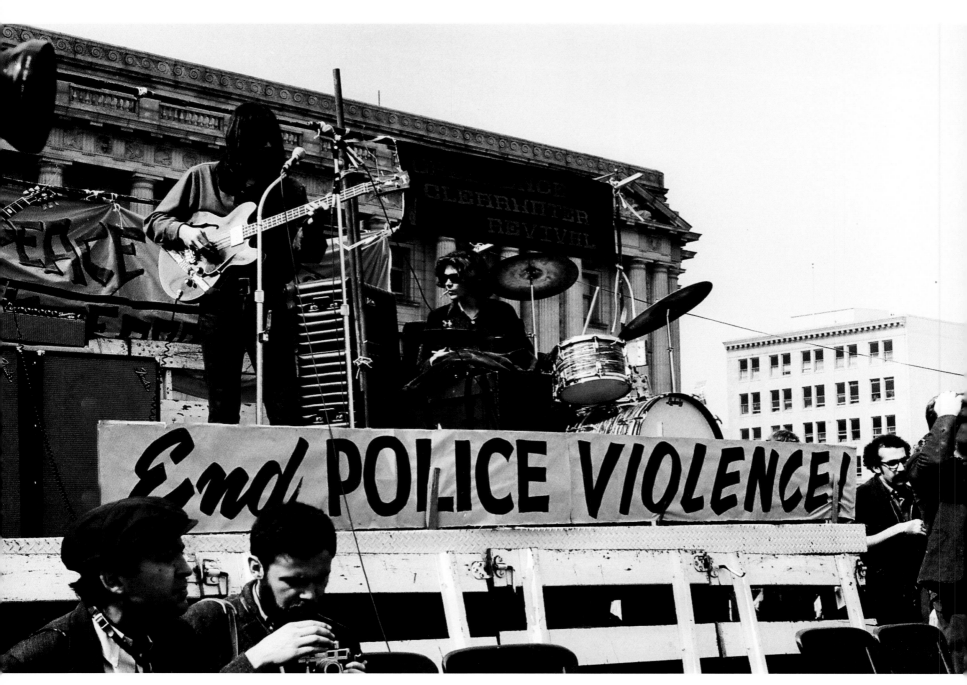

1968: A Year Written in Blood

As the Summer of Love ended, the demonstrations against the war geared up. A "Stop the draft" movement marched on an Army induction center in Oakland, California. Musicians protested through song. Creedence Clearwater Revival was one of the bands that gave voice to the anti-war demonstrations. Though formed in the San Francisco Bay area, their sound was pure Southern rock as well as anti-war. Band members John Fogerty and Doug Clifford had been drafted and both served in reserve units before rejoining the band. They performed one of their signature tunes, "Born on the Bayou," at the Woodstock Festival.

Soon after his LSD trip, Jason headed back east, by train. It was a momentous time for the country and his journey was soon entwined with the events of that year. Fate deemed that Jason's cross-country train would arrive in Chicago two days after the assassination of Martin Luther King Jr., on April 4, 1968. The despair at the death of MLK soon turned to fury and the fury turned to looting and burning. There was a four-hour layover in Chicago before Jason's journey to New York was scheduled to continue.

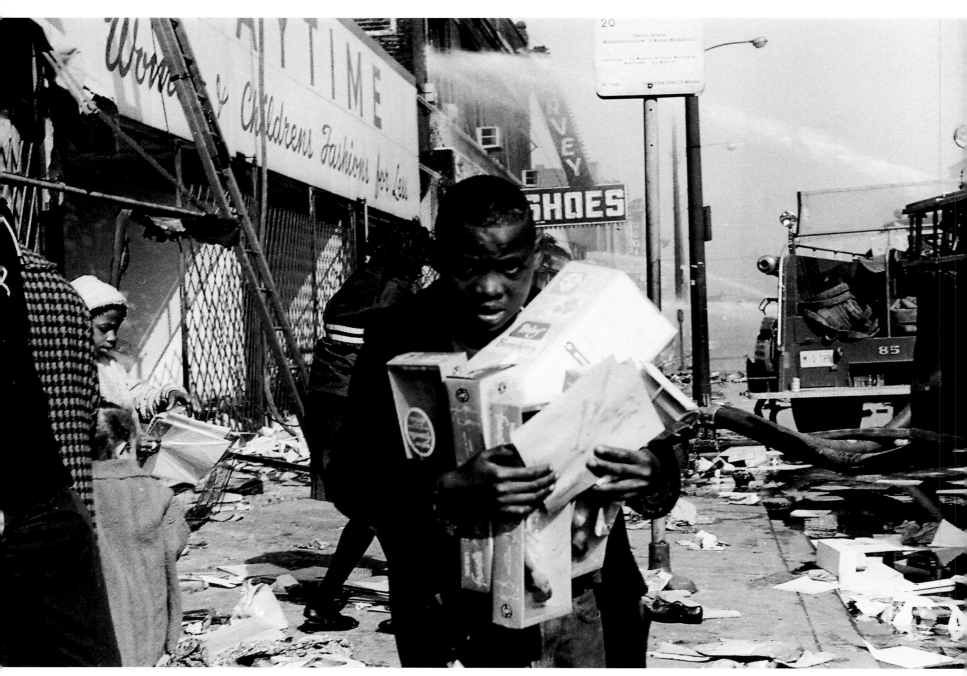

16 Chicago: Aftermath of the assassination of Dr. Martin Luther King Jr.

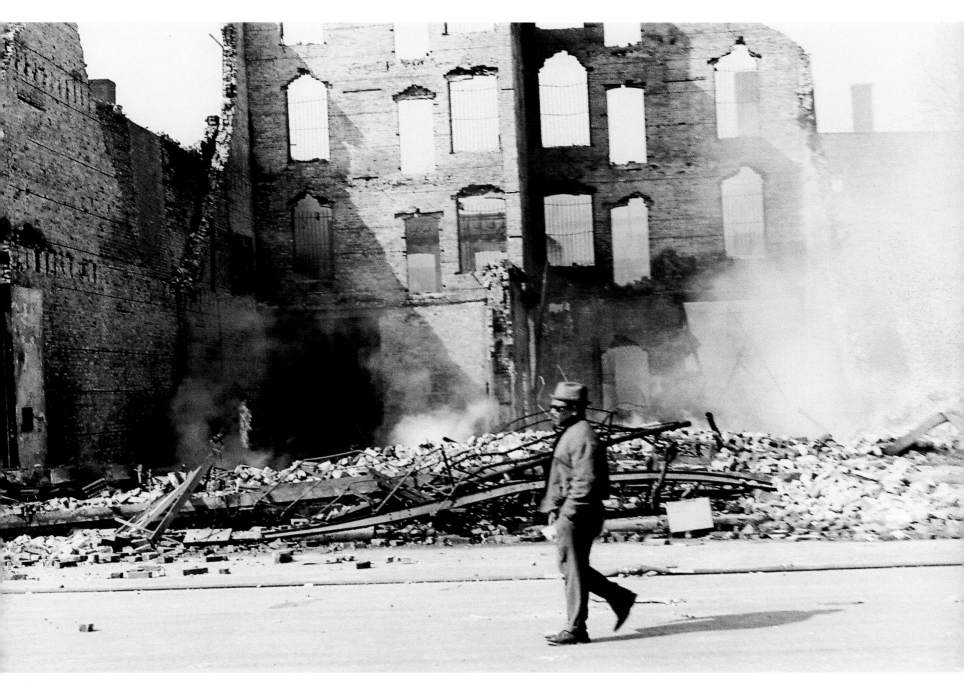

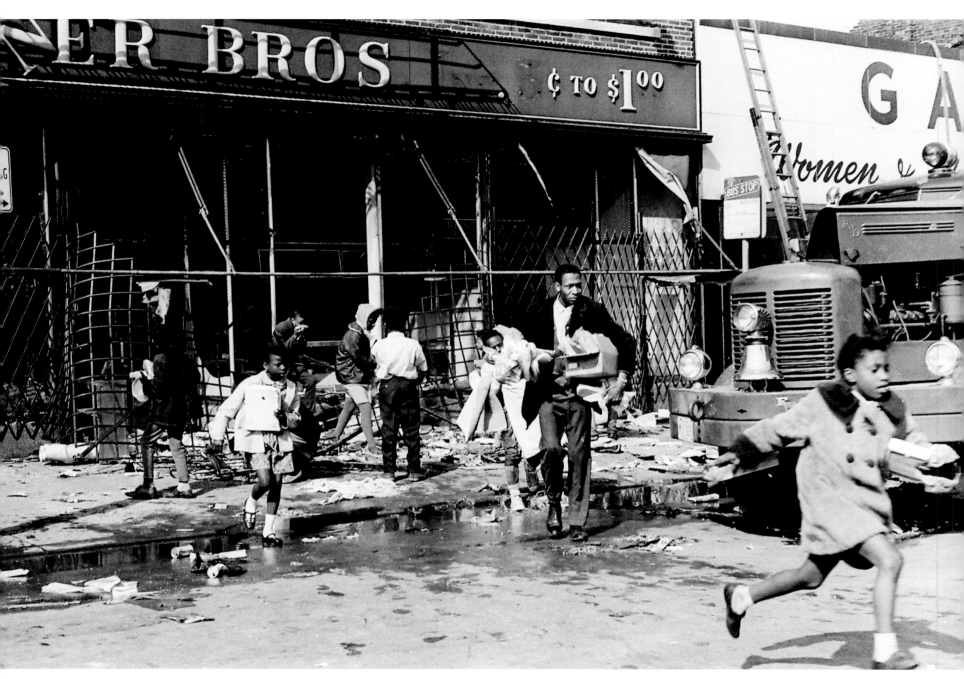

Chicago: Aftermath of the assassination of Dr. Martin Luther King Jr.

Chicago

Jason was barely a photographer at this point. He had shot a total of fourteen rolls of film in his life, including all the work he had done in San Francisco. When the train pulled into Chicago, he bought some black and white film at a drug store in the train station, then grabbed a taxi and asked the cabbie to take him as close as he could to the areas where the unrest was taking place. The driver, who was black, was visibly nervous. After he dropped Jason off, he tore out of the neighborhood as fast as he could.

Jason was nervous, too. There weren't any other photographers around. People were rushing past him, carrying goods looted from the stores. He couldn't make sense of what he was photographing: people burning down their own neighborhoods. He shot two rolls of film including a photo of a young black boy, his arms filled with packaged dolls. A stream of water from a fire truck behind the boy was working on the fire still burning from the row of stores where the looting was taking place.

The next morning, Jason's train arrived in New York. In those days, before the Internet, or computers, or cell phones, or Google, he headed for a phone book and the Yellow Pages. Two phone calls led him to Pix, a photo agency specializing in breaking news. They told Jason to come in with his two rolls of film. Within days, his film was processed and prints were made and sent all around the world. His photos were printed in *US News & World Report*, as well as seventeen foreign publications. Virtually overnight, Jason had become a professional photographer and the course of his life was set on a new trail.

That moment of history was part of a larger movement, a path away from the growing menace of the war in Vietnam and the draft, the involuntary, nearly universal service in the United States armed forces. Massive numbers of young men were needed to appease the insatiable appetite of a war without meaning, without structure and apparently without an end in sight. Some evaded the draft by fleeing to Canada, some received deferments for various reasons, both real and spurious, but most eighteen-, nineteen-,

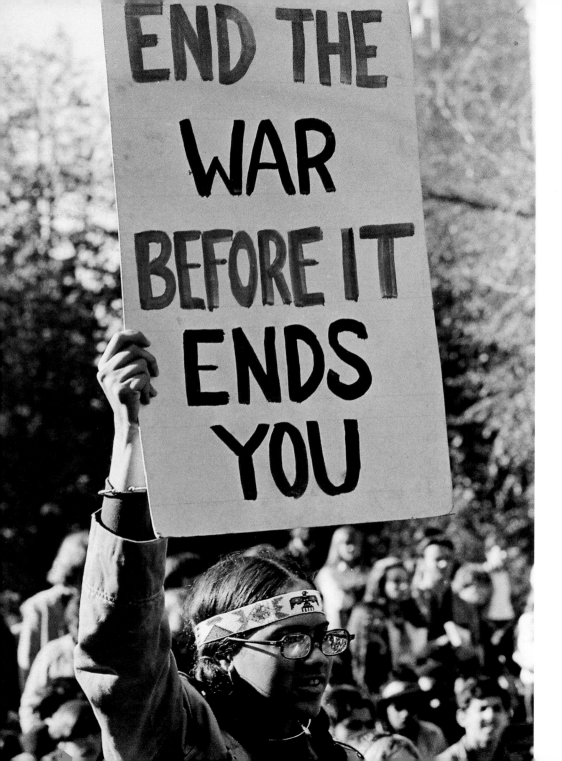

and twenty-year-olds awaited the arrival of the draft notice with an ever-present dread. Old enough to fight, said the government, but not old enough to vote.

When Lyndon Johnson became president in 1963, after the assassination of John F. Kennedy, he inherited a quagmire. The number of US forces in Vietnam in the early 1960s exploded. By 1966, there were 389,000 active soldiers involved, by 1967 there were 486,000, and in 1968 the total topped half a million. Though that was still a small percentage of the total US population of 200 million people, television was bringing the war home to virtually every US household.

Nineteen sixty-eight was a watershed year for the nation, a year in which we lost our innocence in many ways. In spite of that massive buildup of US forces, we were unprepared for the intensity of the war effort on the part of the Viet Cong.

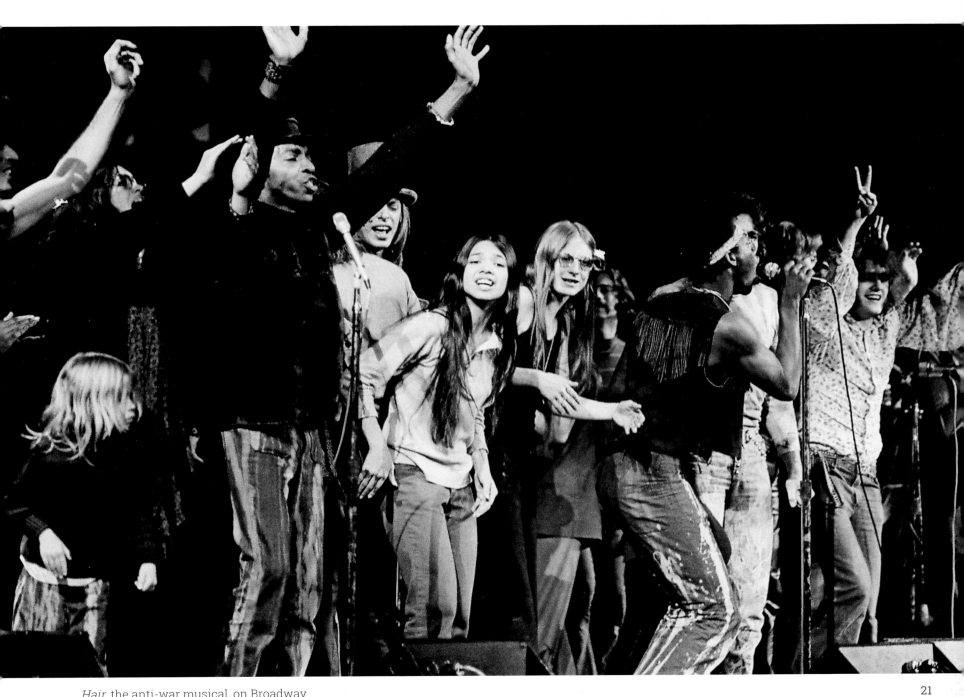

Hair, the anti-war musical, on Broadway

Anti-War Protests

The Tet Offensive of January 1968, named for the New Year's festival celebrated in Vietnam, along with the dramatic escalation of the war, was accompanied by an upsurge in anti-war demonstrations. At universities from coast to coast, young people raged against the decision by the government to send them off to fight, and die, in a war they saw as unjust, while at the same time denying them the right to vote. A sit-in at Columbia University that began on April 26 shocked not only the administration, but the nation. These were truly the country's privileged youth and yet they seemed willing to throw away their education to protest the war.

The heroes had begun to fall. LBJ responded to the toll the war was taking on the nation by announcing he would not run for a second term. Just four days later, on April 4, Martin Luther King Jr. was killed. Then Robert F. Kennedy, the man whom many admired and who was expected to carry on the legacy of his late brother, was shot by an assassin on June 5 and died the next day. And then, at the Democratic Party Convention in Chicago that August, police brutality against largely peaceful demonstrators was televised for all to see. The nation truly seemed to be falling apart and Jason was there to record it.

Ironically, it was all summed up in a musical. *Hair*, subtitled the "American Tribal Love-Rock Musical," captured all the angst and yearnings of the time. Using hippie counterculture as its backdrop, the musical expressed multiple themes: the sexual freedom of the 1960s, the use of hallucinogenic drugs and marijuana, the anti-Vietnam War movement, and above all, resistance to the draft. The show opened off-Broadway, in 1967, at the Public Theatre in Greenwich Village. When it moved to Broadway in 1968 it shocked audiences with a brief scene where the entire cast was nude, as well as with a song celebrating "Sodomy" and other illegal sexual practices, most of which many listeners had to look up in unabridged

dictionaries. But it was the extravagant Afros and dreadlocks that gave the musical its title and remained a lasting symbol of the gap between the generations.

The use of artistic nudity, while shocking to some, fell under the protection of the obscenity laws of the United States, which were so vague that what was considered obscene or lewd in one region was acceptable in another. Most cases related to paintings, sculpture, and literature, not dancing, singing human beings.

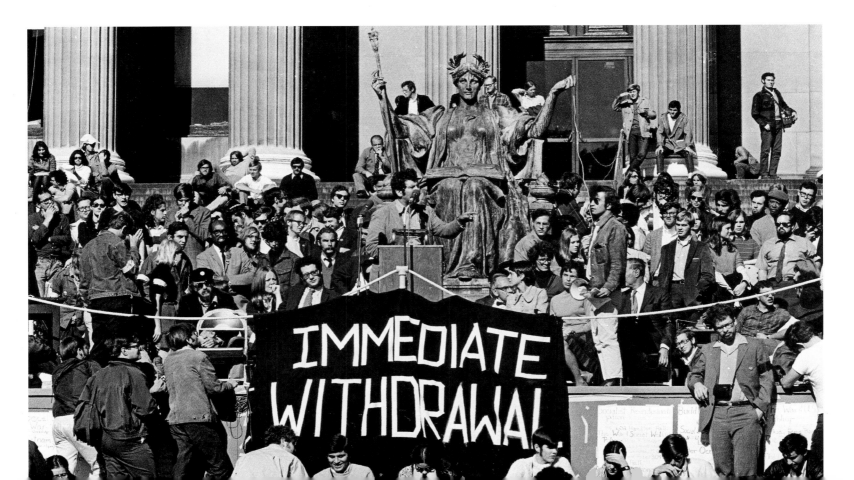

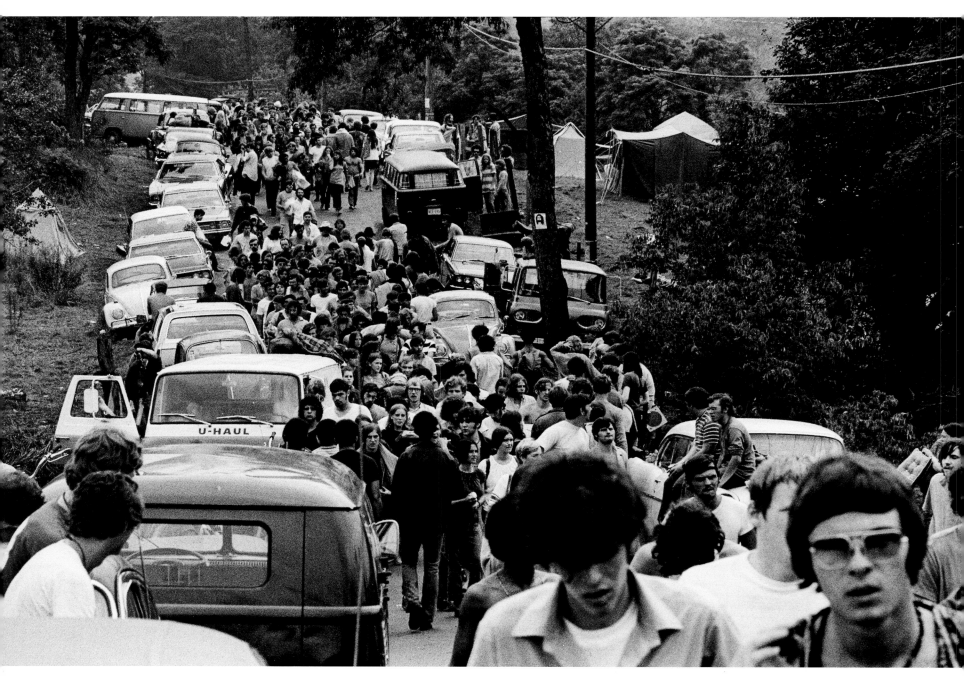

Woodstock: The Festival

Those who say the August 1969 Woodstock Festival was the beginning of a new age, the start of the counterculture movement, were not part of that momentous sea change. The Woodstock Festival was an emphatic, in-your-face symbol marking the end of an era. Those who knew about it in advance had already metaphorically shed their three-piece suits, their button-down collars, and their parents' mores and work ethics.

This three-day-and-night long musical event was a virtually spontaneous gathering of like-minded souls. Young people found their way to the Festival from all the small towns and cities across the United States. Though under the radar of the traditional press, news of the concert made its way into small, largely underground newspapers. The call went out over a nationwide grapevine that something special was going to take place in a place called Woodstock, New York, and you just had to be there. Those who headed

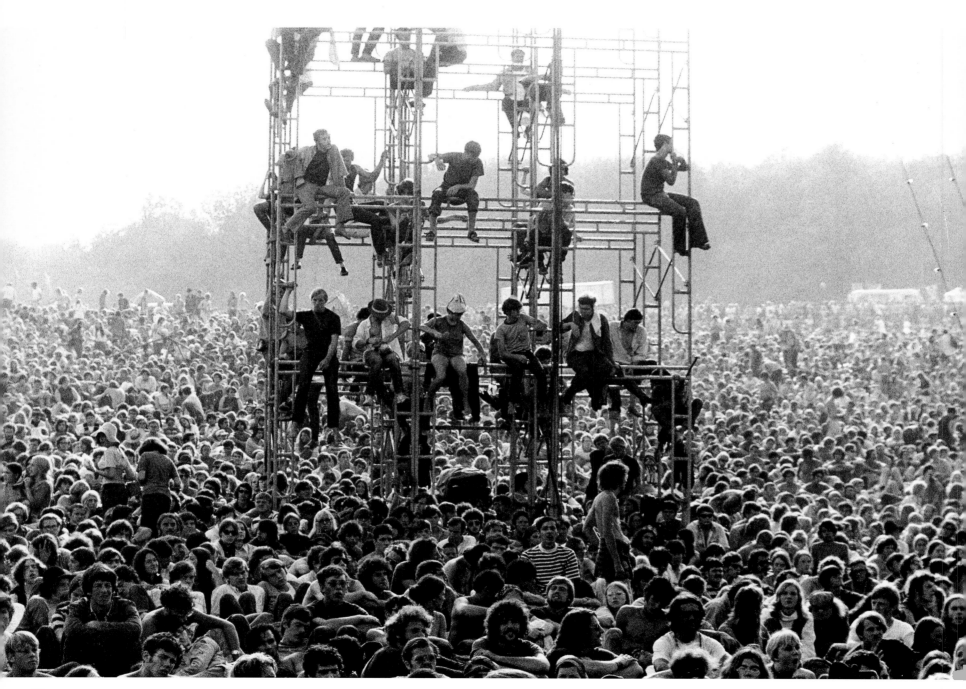

for the Festival weren't concerned about where they would sleep or any of the usual details of daily life. They were pulled along by the thought of the music, the music that defined them and that has endured for the nearly half a century that has passed since those three magical days.

There had been open-air concerts before Woodstock, notably the three-day Monterey Pop Festival in San Francisco in 1967 that attracted a large crowd, and there would be others after it, but none captured the purity of the community that came together at this place, at that time.

The joy of the Festival, the delight in the music, the communal living, all created a sense of community on a scale that had never been seen in America before. Hundreds of thousands of words have been written trying to explain why it worked, why it didn't disintegrate into a mob of people who were angry because they didn't have enough food, a dry place to rest, or a place to wash. Instead, there was harmony and helping, cooperation and sharing, peace and love. It

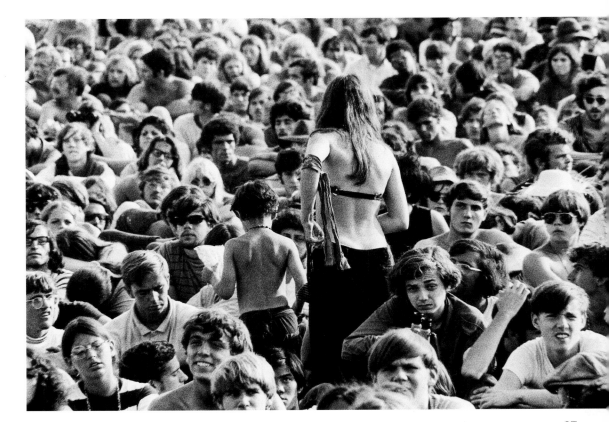

was a moment that transcended the conditions, lifting that crowd to a higher place. As evidence of its unique status in music history, though the organizers had sold tickets for a crowd estimated to reach fifty thousand, the massive influx of hundreds of thousands quickly turned it into a free festival. Those original tickets are now precious collectors' items.

The Festival stood for nothing more than itself. One small irony of the event, among many, is that it took place in Bethel, New York, not Woodstock. Although a permit had been issued for the festival to be held in Woodstock, already known as an artists' colony, the townspeople grew nervous as the time approached and feared they would not be able to handle the enormous number of people. Some simply did not want a rock music festival in their town at all. Instead, unsung, unknown, unheralded Bethel played host to the half million or so revelers on Max Yasgur's farm. Dairy farmer Yasgur turned out to be more like the incredible horde who came to call his land home for three days than could be expected of a forty-nine-year-old more used to the dawn-to-dusk life of a farmer than the all-day and all-night festival that unfolded there.

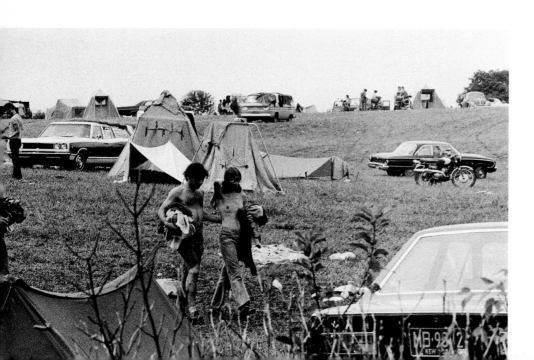

The gently rolling hills, usually planted with alfalfa or corn to feed dairy cows, provided the perfect amphitheatre on which to set up a stage and then encompass all those spaced out, free loving, comfortable boys and girls. No one raced out to print up "Bethel" banners

or clothing. There were no "I survived three days at Woodstock" T-shirts. There were no signed guitars for sale. All that mattered was being there.

And the bands. What a once-in-a-lifetime gathering of the musical tribe-of-the-day it turned out to be. There were bands just beginning to be known, bands with reputations, and bands no one had ever heard of before. Some made an appearance and disappeared. Others made their reputations just by being there.

The crowd was a living organism, one that made its own rules as it went along. One of the important life-changing elements turned out to be the sheer impossibility of driving to the event along the conventional route of the New York State Thruway and then Route 17B.

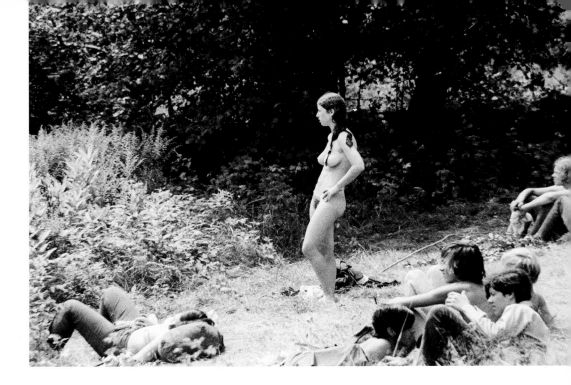

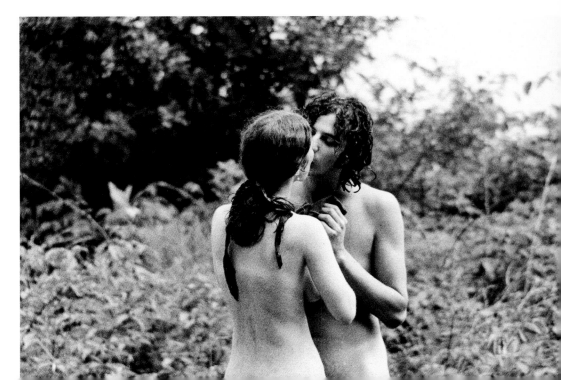

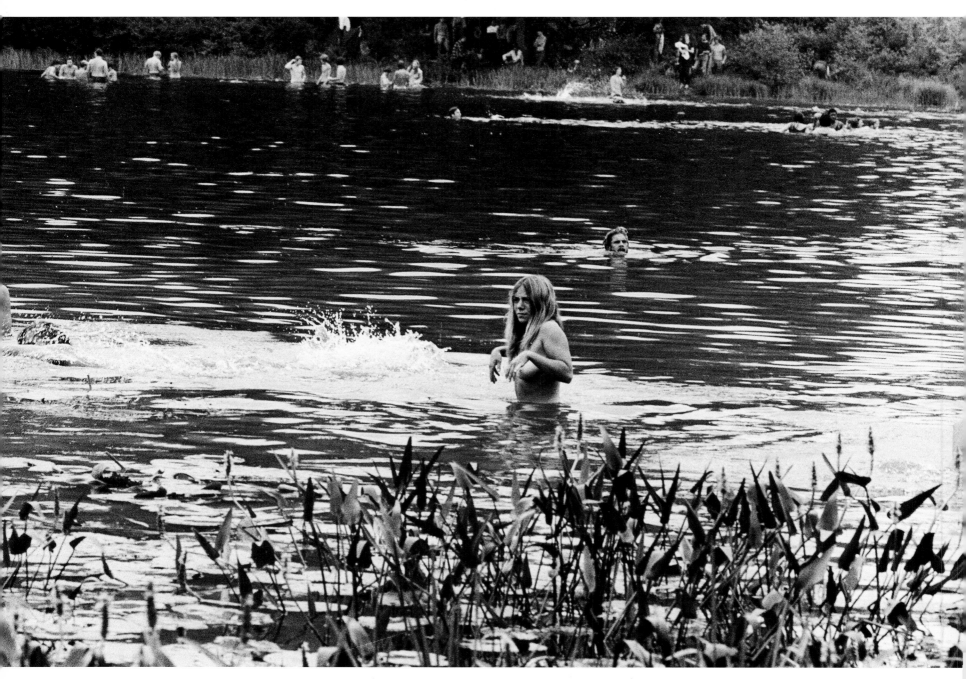

Neither the great super-highway, with its smooth multi-lane road nor little two-lane Route 17B could accommodate the crush of motley vehicles bringing in the music lovers. Well short of the venue, many abandoned their minivans, campers, trucks and cars, turning the roads into inadvertent parking lots. They hiked the rest of the way in with their bedrolls, backpacks, and meager supplies. They were aided by the townspeople, some bemused, some concerned, but all of them generously helping the thousands of ill-prepared, trusting waifs who passed by, smiling and flashing the ubiquitous peace sign. They were joined by the local and state police who, though outnumbered on an epic scale, quickly realized that this was a crowd like no other and needed a very different kind of policing—mostly hands-off until someone fell ill or was injured. These kids became everyone's kids.

They set up communal living areas, spontaneously, washing in the pond on Yasgur's farm. The unselfconscious nudity on display evoked the Garden of Eden, before Eve bit into the apple of knowledge. Though living conditions were bare and basic, the mellow crowd coped with rainstorms and the resultant mud with remarkably good humor, made possible by copious amounts of marijuana and drugs.

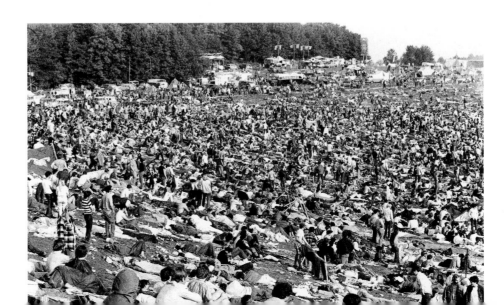

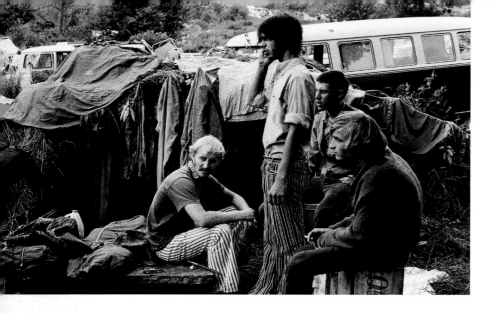

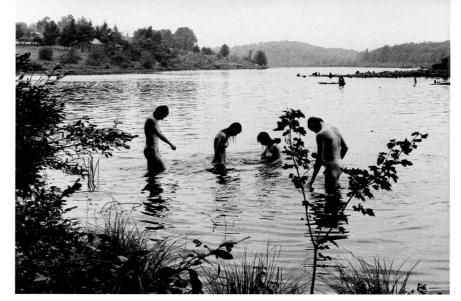

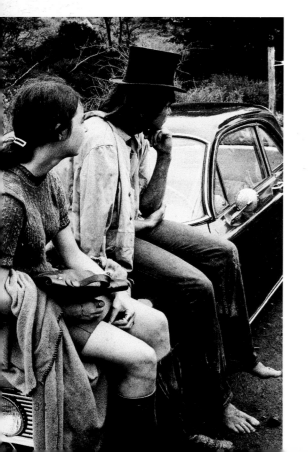

The carefully designed list of bands was abandoned as quickly as the cars. Now the order of play depended on whoever managed to get there with their instruments. Tuning up, rehearsing, getting ready physically to appear in front of the largest crowd, by far, that any musician had ever seen, it all took a backseat to logistics.

The sun was shining metaphorically on Richie Havens that first day, August 15, as he became the unscheduled opening act for an audience that filled every available inch of the rolling fields dedicated to the event. He was spectacular—and he was just the start in a lineup that was the ultimate rock music lover's wish list. There were Janis Joplin and The Who, Sly and Santana, and Grace Slick. This was truly musical heaven on a hillside.

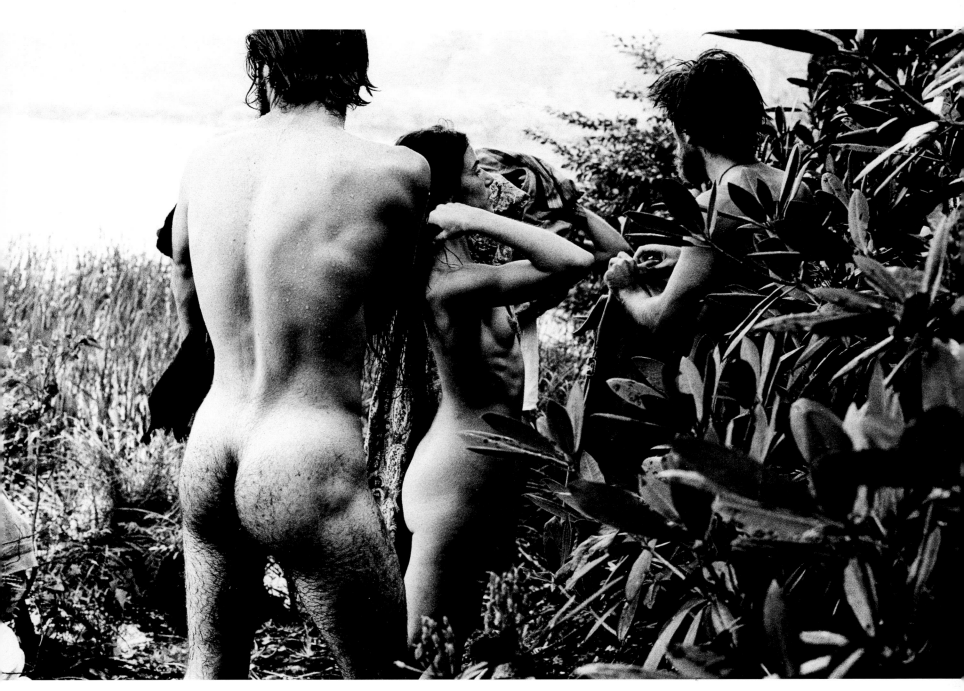

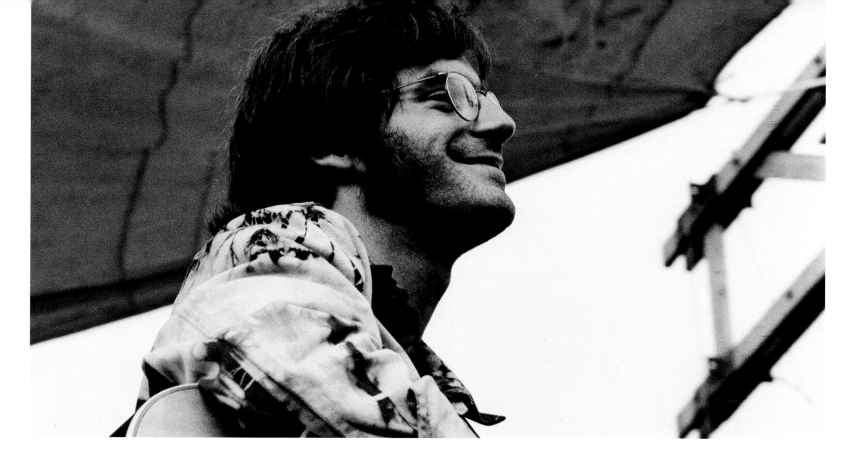

John Sebastian

John Sebastian had traveled to the Festival from his home in Woodstock to support musician friends who were on the program. The rain, however, was proving to be a real threat to the plugged-in electrical guitars and other equipment. The stage was full of water and the organizers needed time to clear it so they could set up for the next scheduled group. The organizers begged Sebastian, well known as a member of the Lovin' Spoonful, to perform as a solo act. He borrowed an instrument from another musician, went out on stage and made some history.

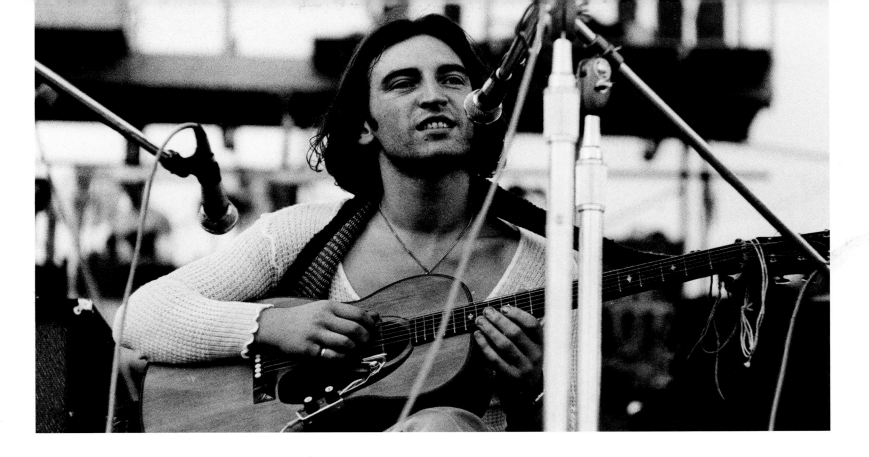

Incredible String Band

The unique sound of the Scottish group, the Incredible String Band, is known as psychedelic folk music. Their sound was well suited to the mood of the era, but it made for a dramatic contrast to the harder rock music previously on stage. They stood out, too, for their exotic musical instruments and costumes. Their appearance at Woodstock should have been on the first day of the Festival when the folk music acts were scheduled. Instead, they asked to be held to the next day, when the rain had stopped. Though the weather was better for their instruments, the crowd's reception to them was muted.

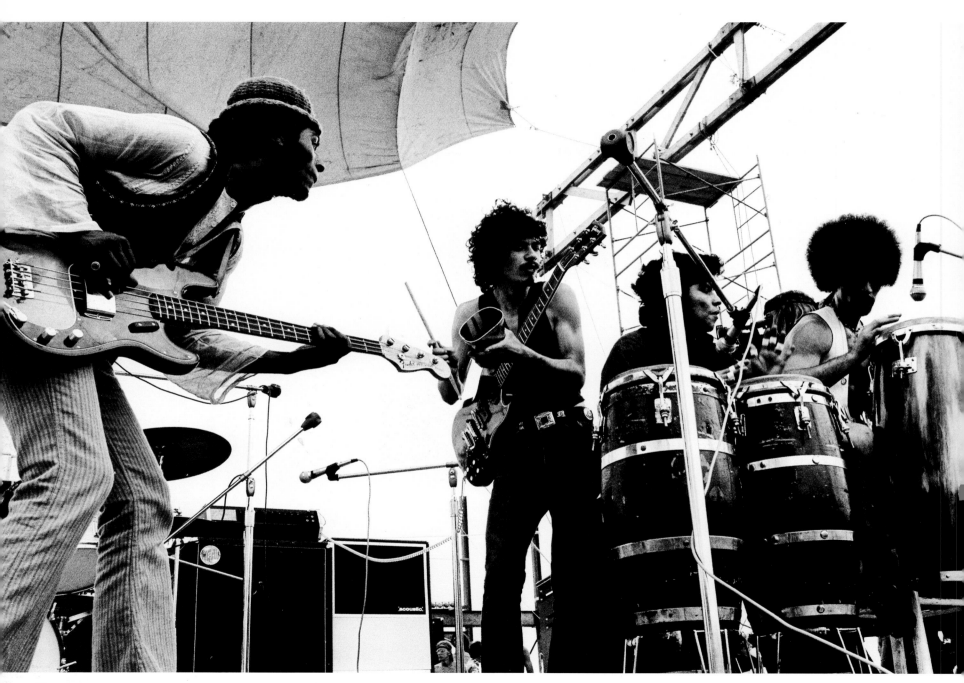

Santana

While some groups and individual artists were well known to the crowd, Carlos Santana and his band were virtual unknowns on the East Coast. Their first album had yet to be released so when they stepped onto the stage in front of that endless sea of people, no one could have guessed that history was about to be made. Later, Carlos Santana would say, "The music made the people move like leaves in a field." The band's percussive rhythms and new sounds reverberated throughout their eight-song set. It probably helped that Santana was as high as many members of the audience.

Santana was honored at the Kennedy Center in 2013 and is also the recipient of a star on the Hollywood Walk of Fame.

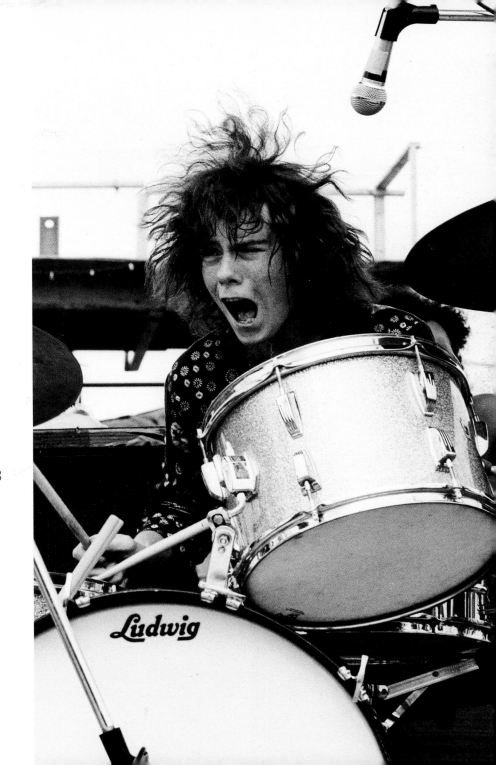

Drummer Michael Shrieve

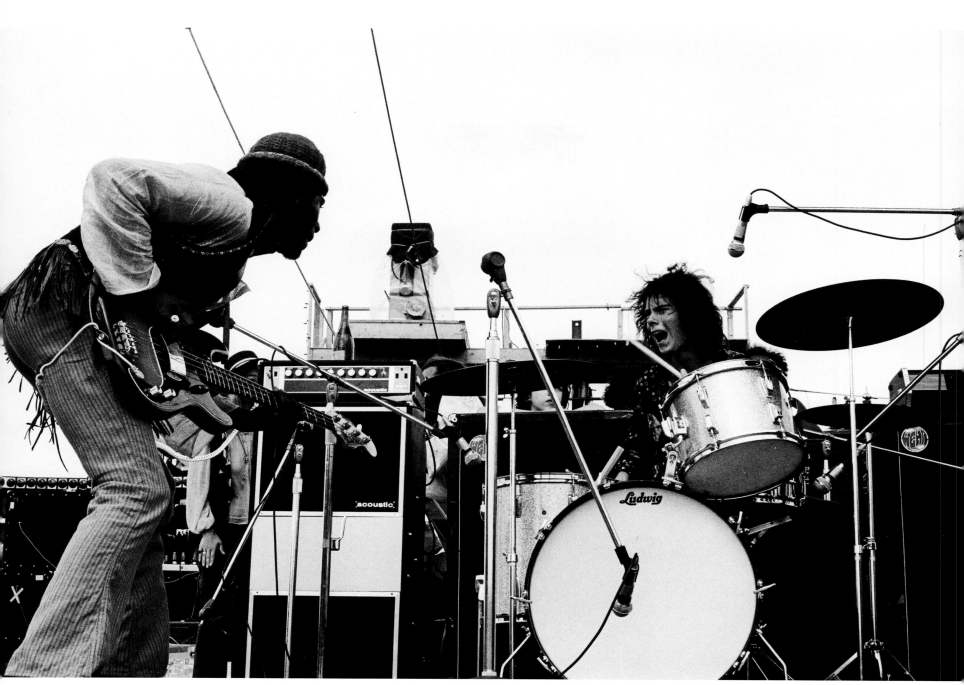

David Brown on guitar, with Michael Shrieve

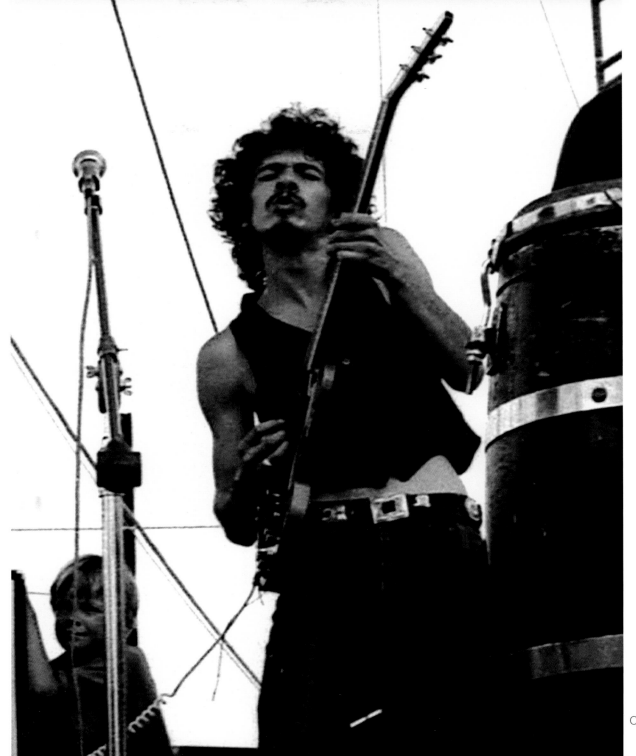

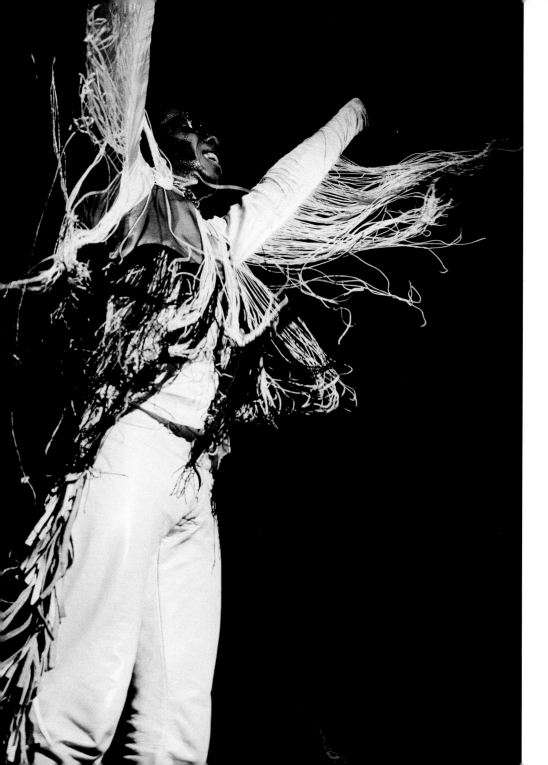

Sly and the Family Stone

The electricity created by Sly Stone and his psychedelic funk style survived a six-hour delay in getting on stage. Even at 3:30 on Sunday morning, he got the sleepy crowd out of their sleeping bags and onto their feet. No one could resist his charismatic personality, his unique style, or the driving beat of his songs. Like a fervent Sunday preacher, he thrilled and excited the crowd, culminating in his "shout and response" version of "I Want to Take You Higher." With the long fringes on his white outfit flying with every gesture, he was the essence of a larger-than-life showman. His message of peace and love was spiced with a black-consciousness that enthralled the largely white audience.

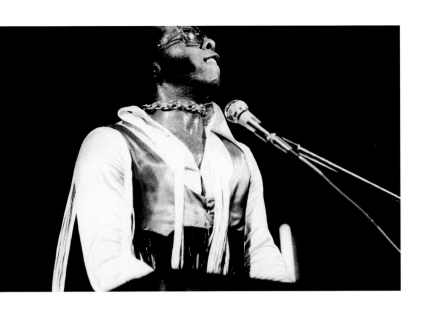
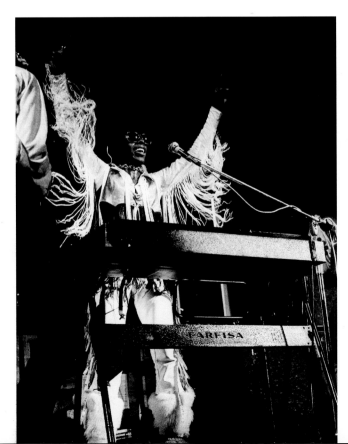
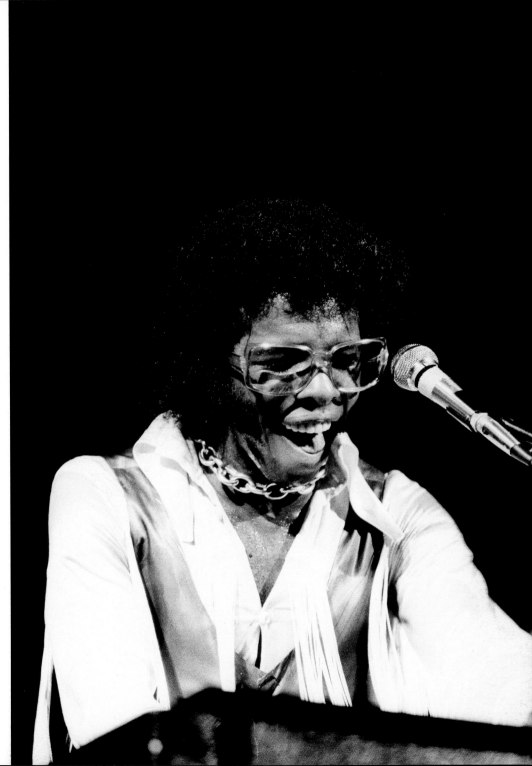

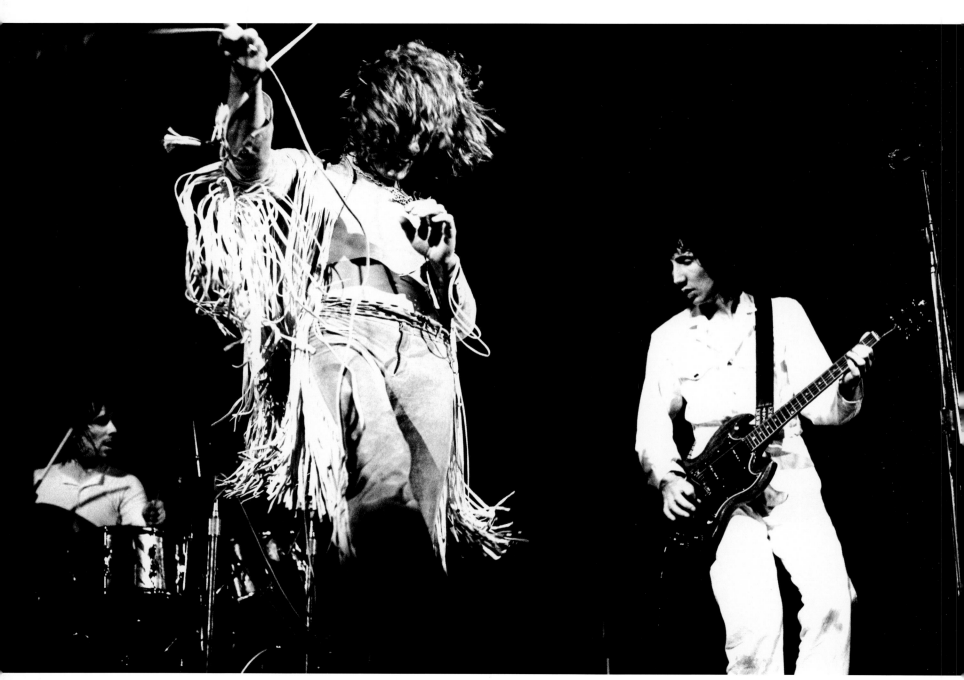

42 Roger Daltrey, drummer Keith Moon, guitarist Peter Townshend

The Who

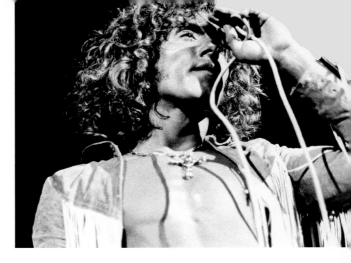

The astonishing show put on by Sly and the Family Stone, which ended at 5:00 in the morning, could only be followed by an act as big as The Who, and they did not disappoint. Although The Who had been around since 1964, like several of the other starring acts at Woodstock, this UK band first became known at the 1967 Monterey Pop Music Festival. In addition to the popular song "My Generation," many of the songs they played at Woodstock came from their rock opera, *Tommy*. Since the Festival never caught up with the lateness caused by the weather and the immense size of the crowd, acts found themselves waiting for hours to go on. In spite of this, The Who played for hours, and as dawn rose over the scene, Roger Daltrey's fringed shirt picked up the colors of the early morning sunrise.

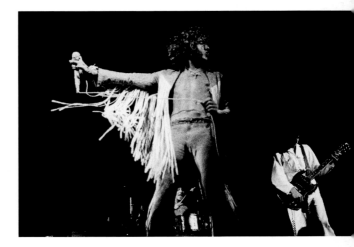

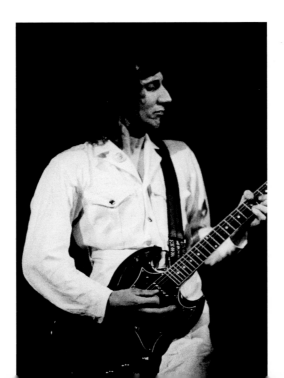

In 2016 they marked their 50th anniversary with a US tour, including an appearance at Madison Square Garden in New York City.

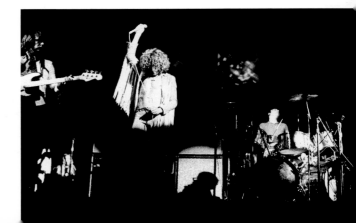

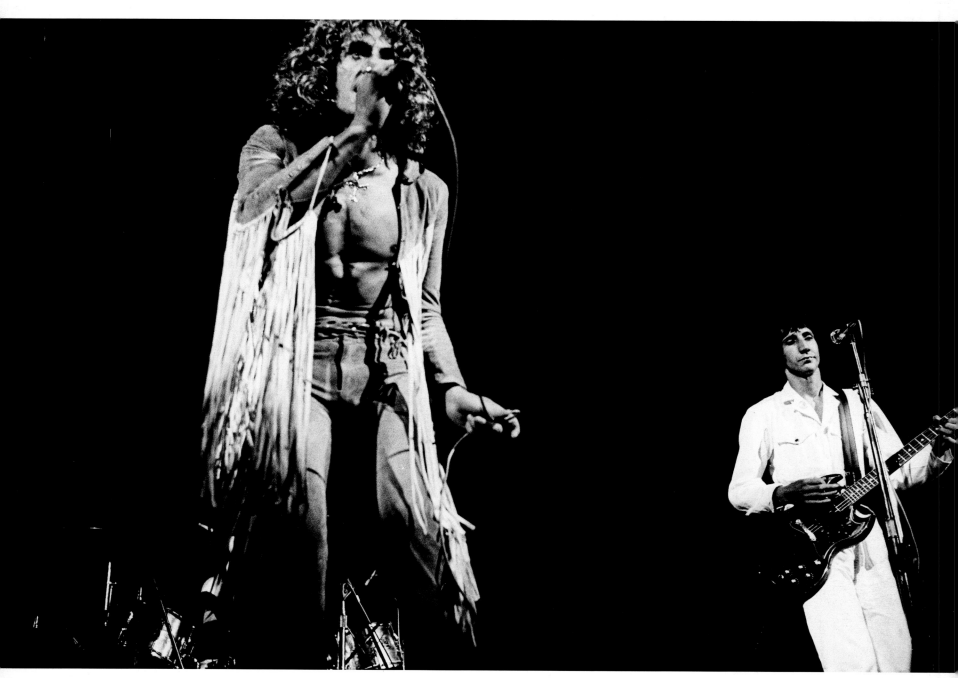

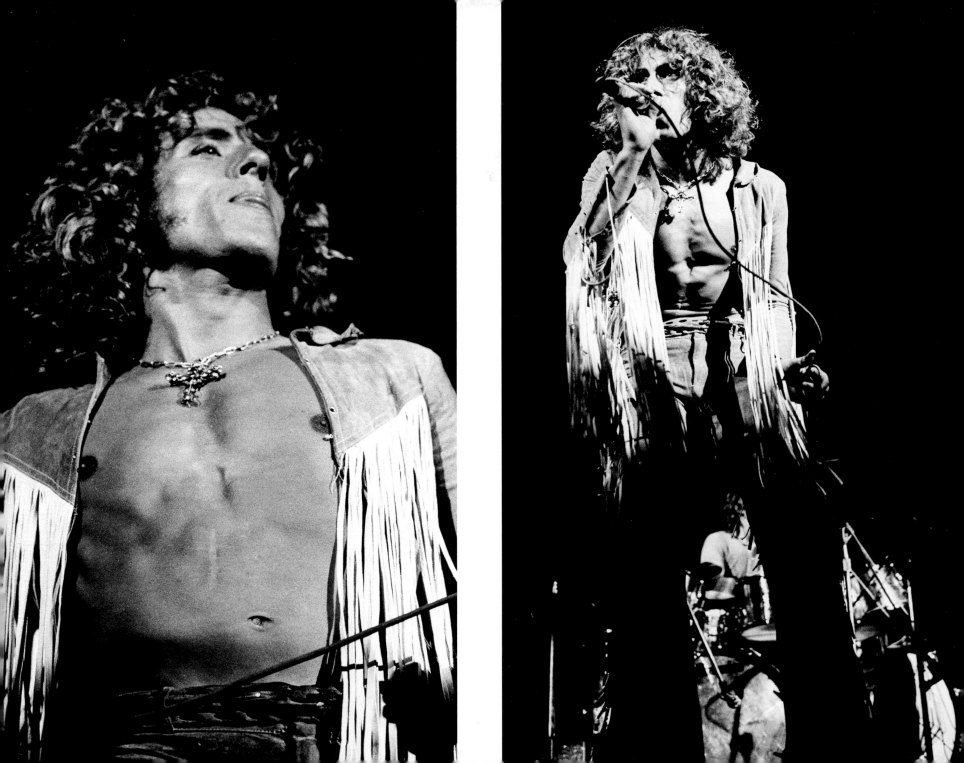

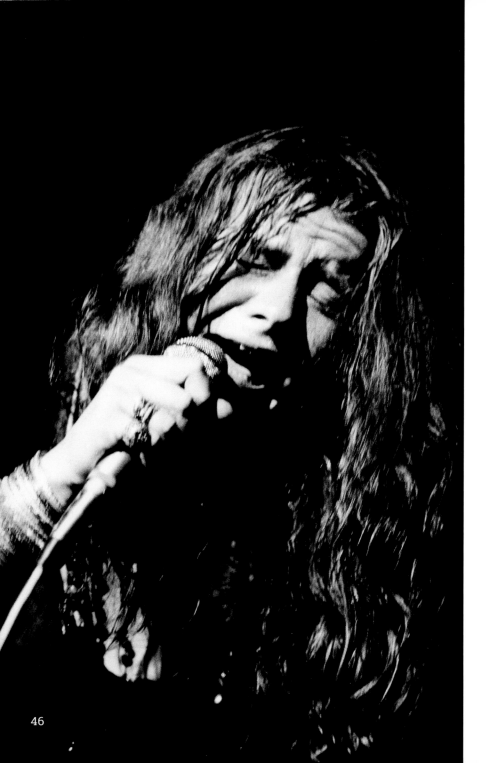

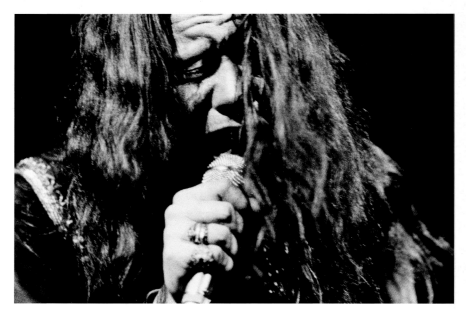

Janis Joplin

This charismatic blues singer from Texas thrilled audiences with her raw, exciting, and almost out-of-control style. Joplin lived hard and it showed when she was onstage. She had dazzled West Coast audiences as a member of Big Brother and the Holding Company. With her new band, Kozmic Blues, she performed a ten-song set and although some felt that the hours-long wait before the band went on somewhat subdued her performance, she made an indelible impression on the crowd and in the subsequent "Woodstock" film.

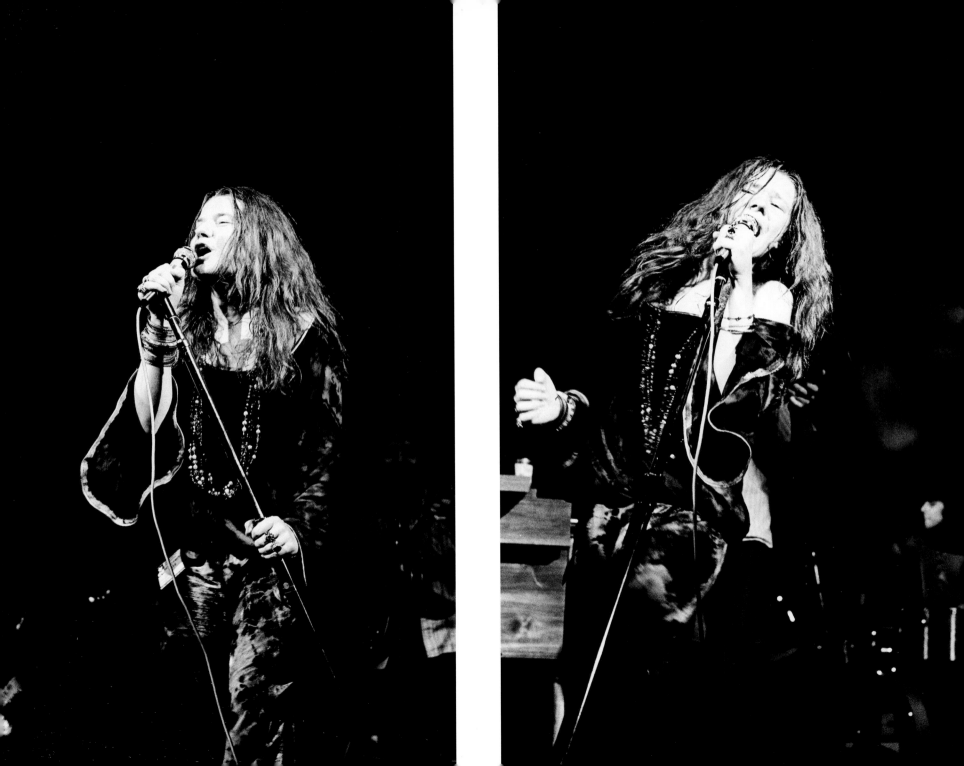

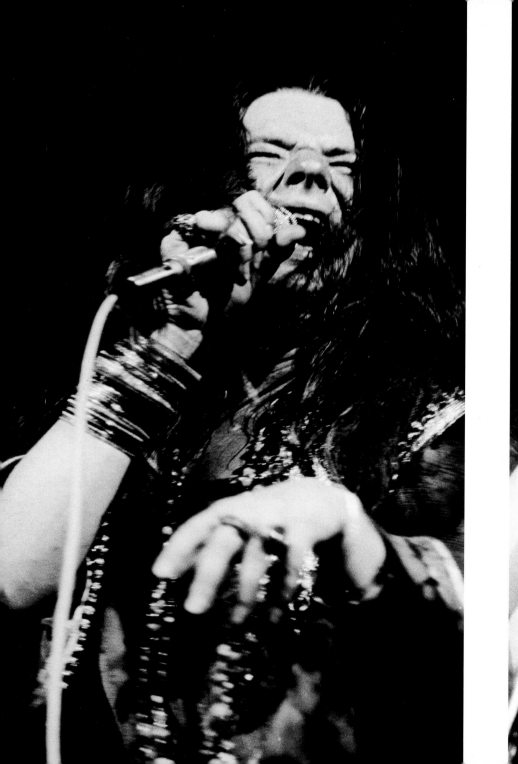
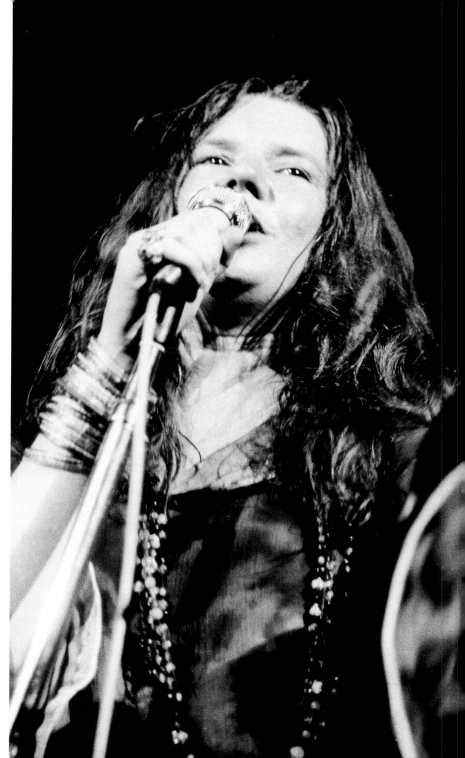

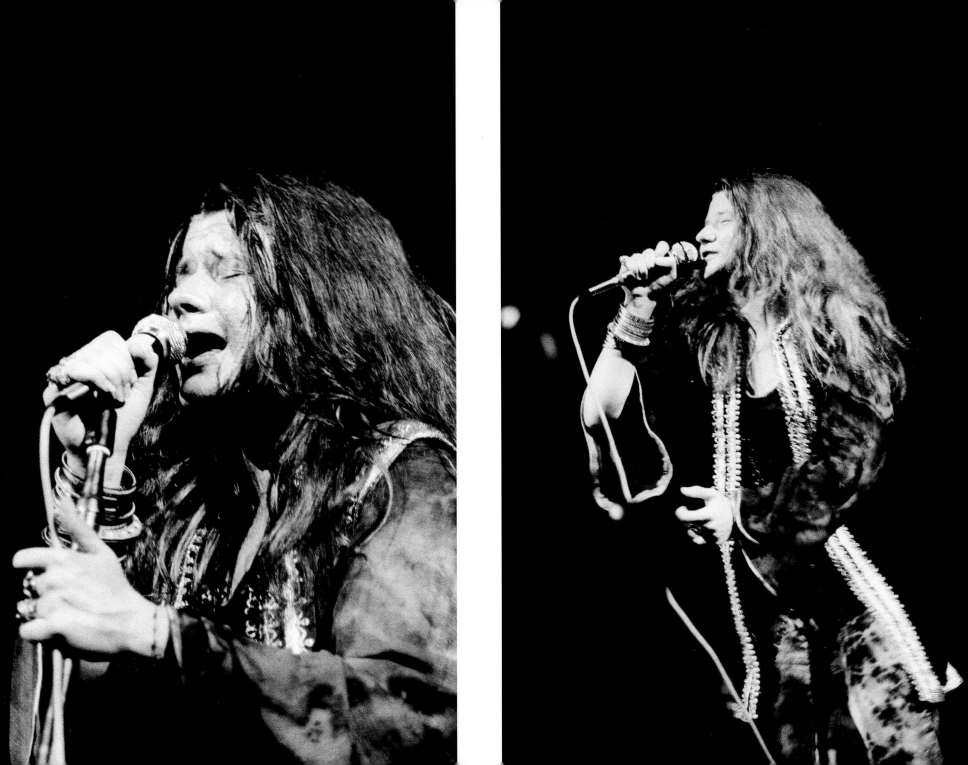

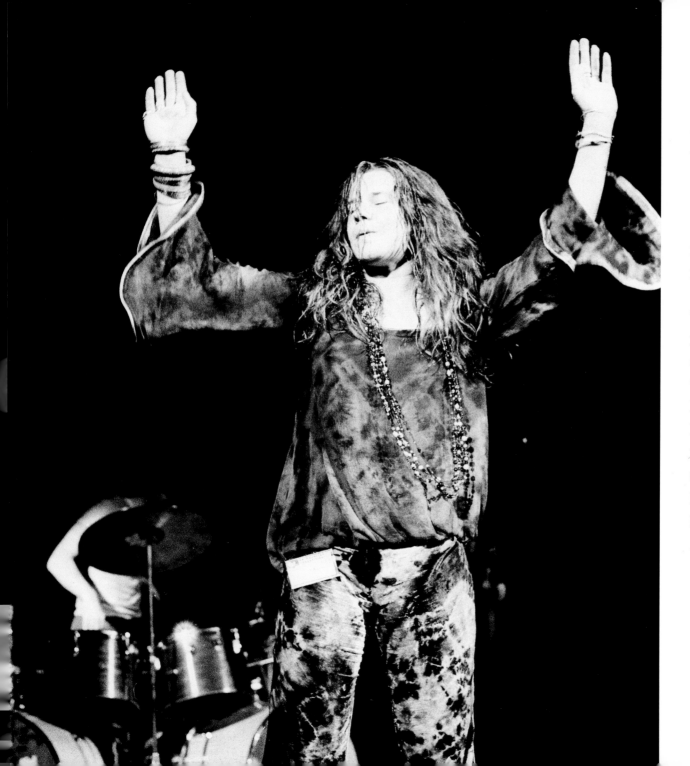

This was a star that blazed briefly and then, all too soon, was gone at the age of twenty-seven, the unlucky number for so many meteoric performers.

Though the star herself is gone, her music lives on. In 2014, forty-four years after her death in 1970, her life, her look, her sound, and her style were all brought to life in a stunning re-creation by Mary Bridget Davies, in a Broadway play called *A Night with Janis Joplin*.

Jefferson Airplane

Another West Coast favorite, Jefferson Airplane, with its ethereal lead singer, Grace Slick, would soon become known for its psychedelic song, "White Rabbit." Their start time and placement, 7:00 on a Sunday morning following Sly Stone and The Who, certainly didn't help. But they certainly woke up the crowd. Soon after its appearance there, the band morphed into Jefferson Starship and played on and off under that name, with a revolving cast of members, for three decades.

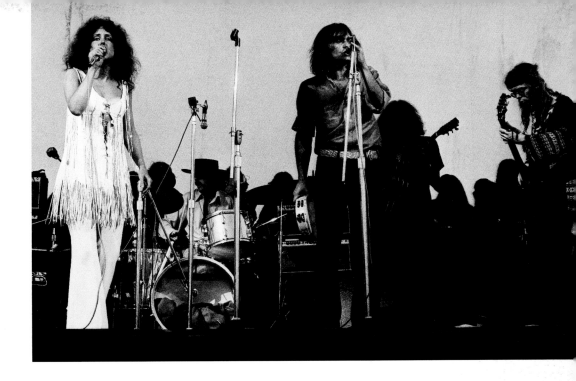

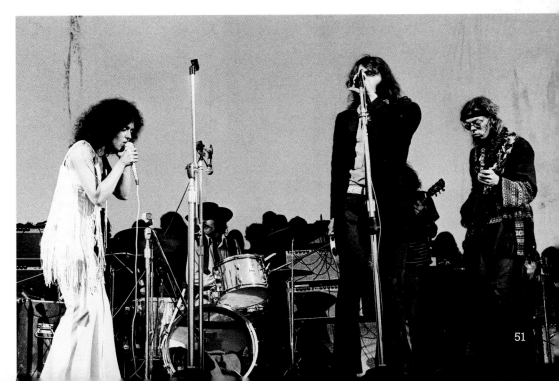

51

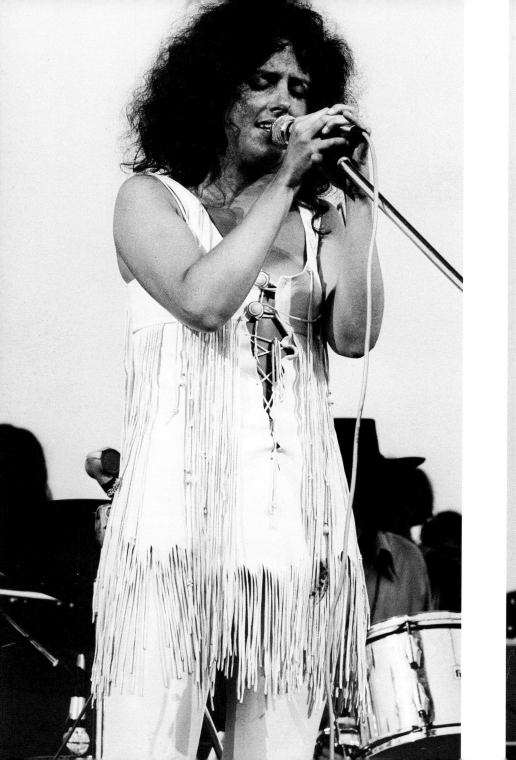
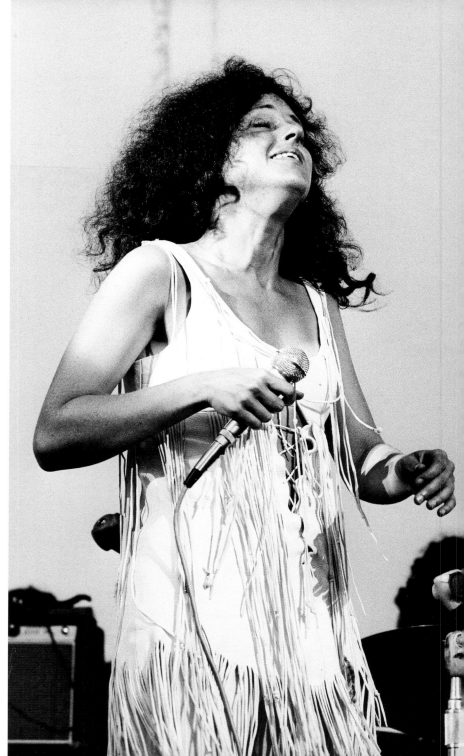

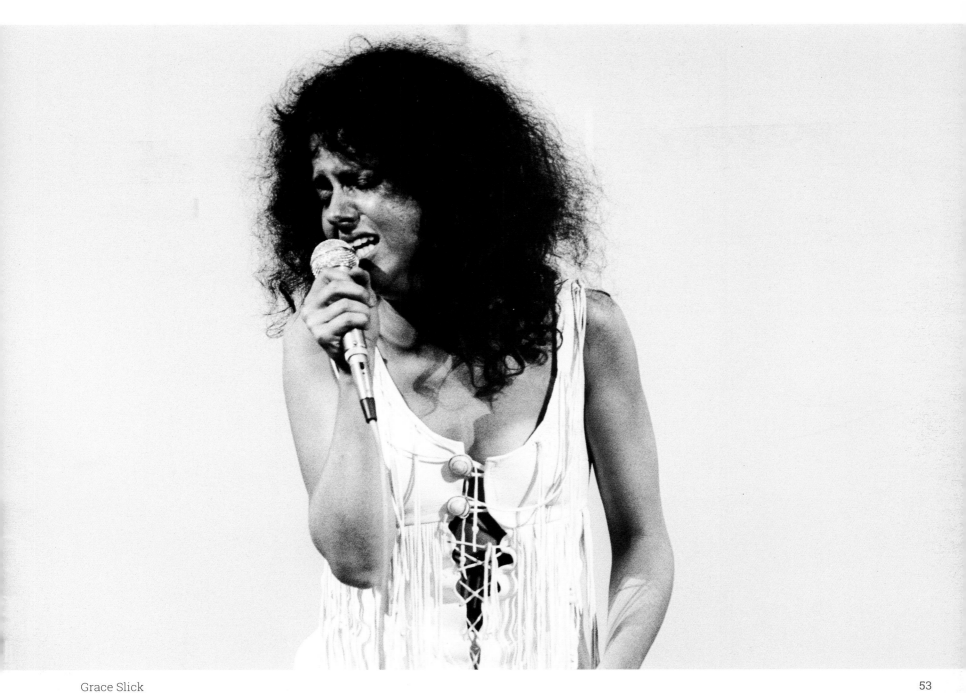

Grace Slick

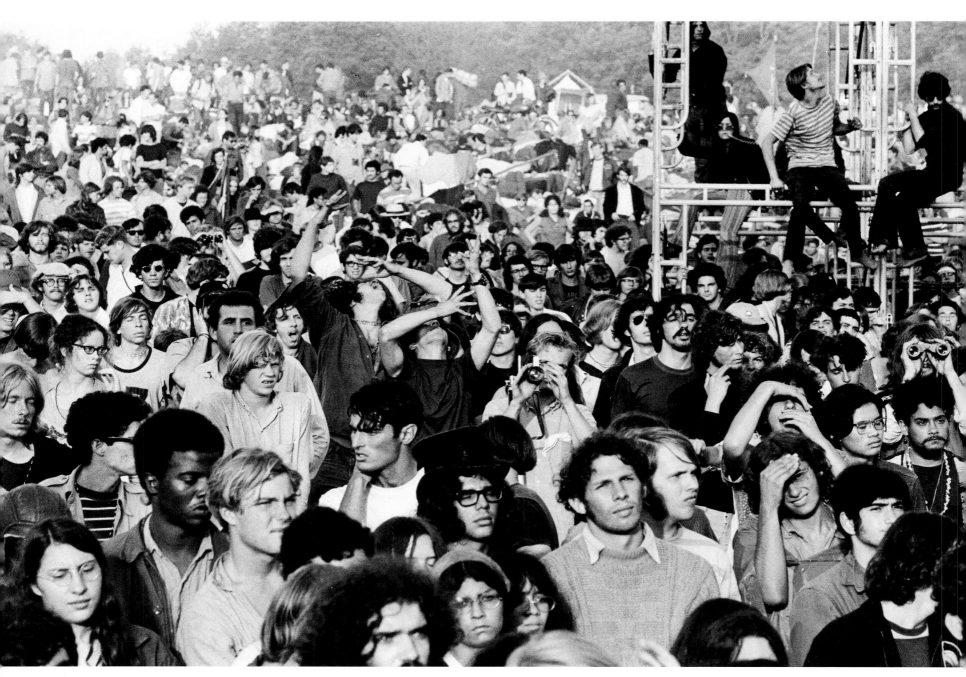

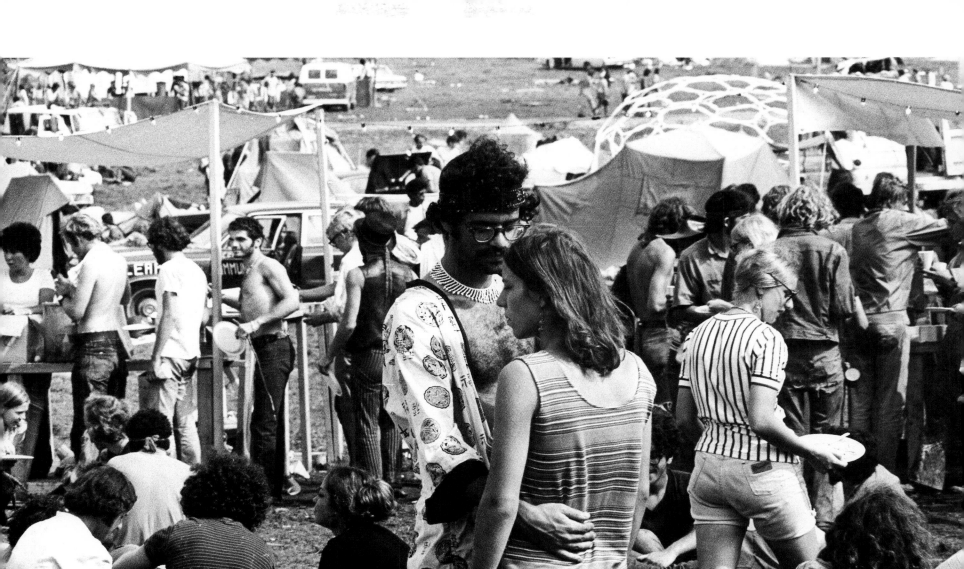

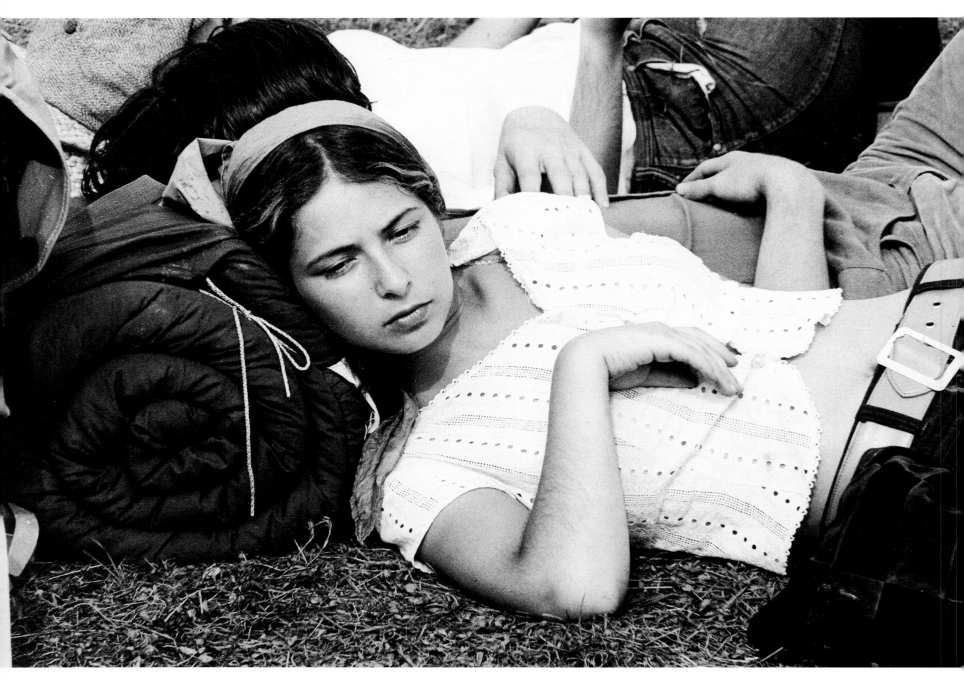

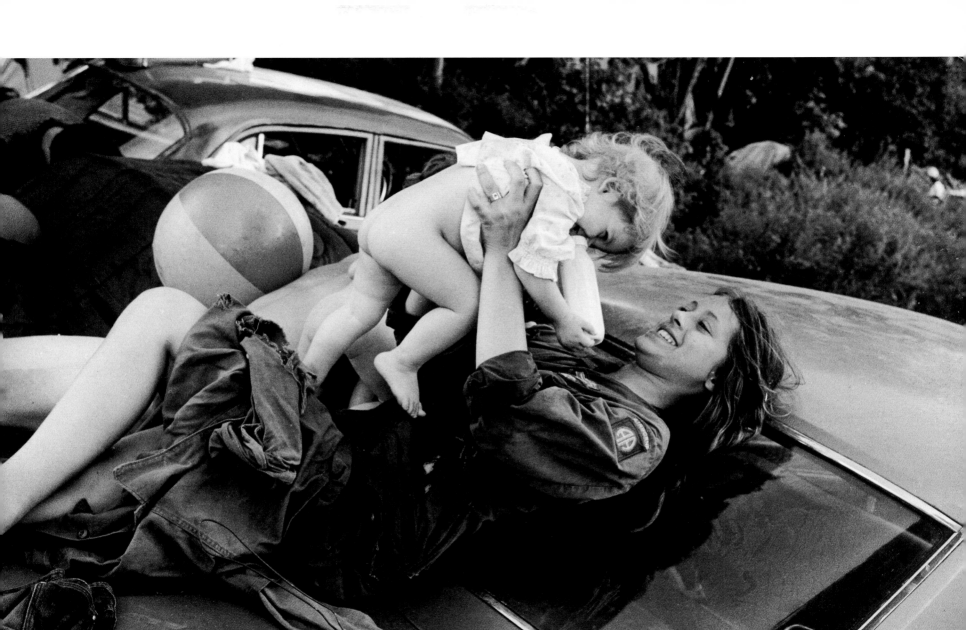

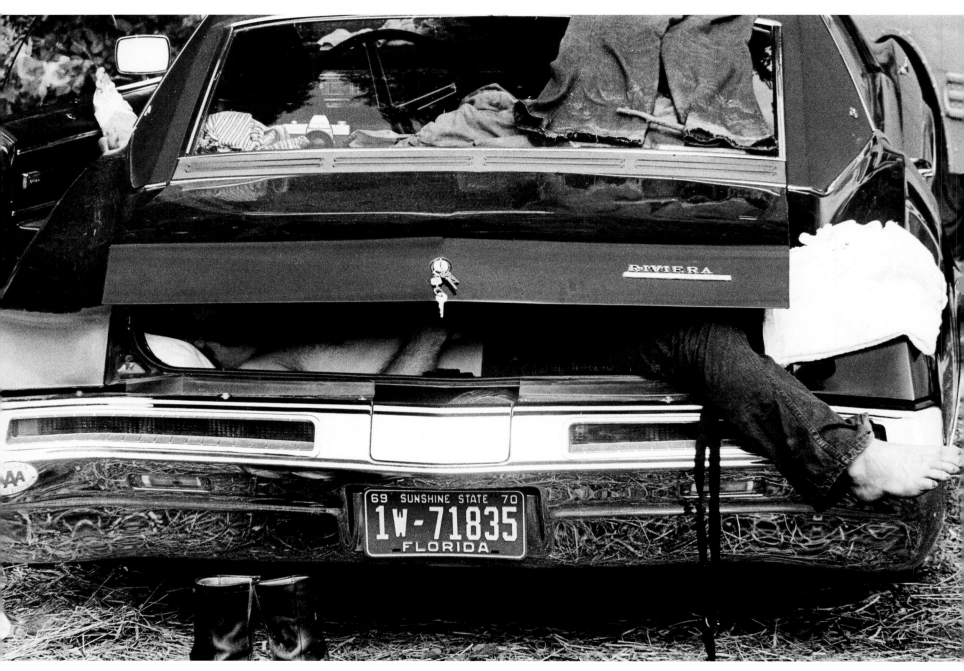

CHAPTER FOUR

Woodstock in Color

Jason drove up to the Festival from the city with a journalist friend. Like most of the people who made it there, they left the car somewhere on Route 17B and walked the rest of the way to the site. Jason had a credential issued by the folks from the Hog Farm that allowed him access to the performers on stage.

For three days and nights he moved between the crowds, the stage, and the tent city, somehow going back and forth. To this day, he cannot say how he did it. He doesn't remember sleeping, but he also doesn't remember being tired. He doesn't remember eating or drinking, but he doesn't remember being hungry or thirsty. The electrifying music, the messages that the music conveyed, the sheer artistry, all merged into one glorious moment.

And yet, when he looks at his thirteen rolls of black and white film, and his eight rolls of color, it's all in focus. Jason shot the bands mainly at night, with the dramatic nighttime background.

With the music as a glorious backdrop, Jason spent a day at the pond and the communal living areas, photographing people who were simply enjoying themselves. There was space here to frolic, to bathe, to dry off and walk around naked, to be with loved ones and find new loves, even if those relationships only lasted as long as the music. It was as if every teenager or twenty-something who felt out of sync with the town where he or she was growing up realized that they were not alone, or odd, or even unconventional. They simply hadn't found their true contemporaries before they landed at the Festival.

To photograph live bands, with the constant movement on the stage, the changing lighting, the glint of light or sun on the instruments, was both a challenge and a delight for him. Jason learned to anticipate the lead singer's movements as he got into the rhythm of the songs.

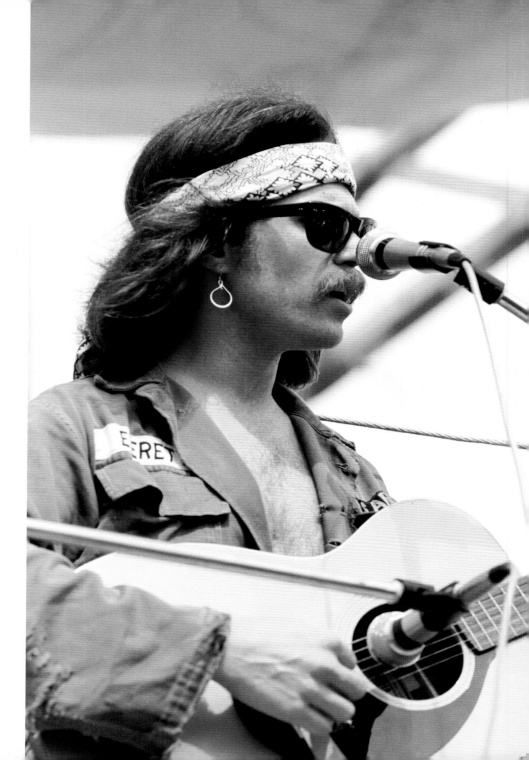

Country Joe McDonald

With his borrowed Army jacket, headband, and earring, Country Joe McDonald evoked the spirit of the times in spite of having served three years in the US Navy. He was vehemently against the war in Vietnam and he made his opposition clear through his music, especially his ironic and sardonic lyrics in "I-Feel-Like-I'm-Fixin'-to-Die Rag." Singing to a vast audience of draft-age boys and the girls they would leave behind when sent to fight in Vietnam, he sang about boys coming home in body bags, one of the saddest recurring images of the war. In one of the verses, he sang:

Come on mothers throughout the land,
Pack your boys off to Vietnam
Come on fathers, and don't hesitate
To send your sons off before it's too late
And you can be the first ones in your block
To have your boy come home in a box.

Then the chorus went:
And it's one, two, three what are we fighting for?
Don't ask me I don't give a damn
Next stop is Vietnam.
And it's five, six, seven, open up the pearly gates,
Well there ain't no time to wonder why,
Whoopee! We're all gonna die!

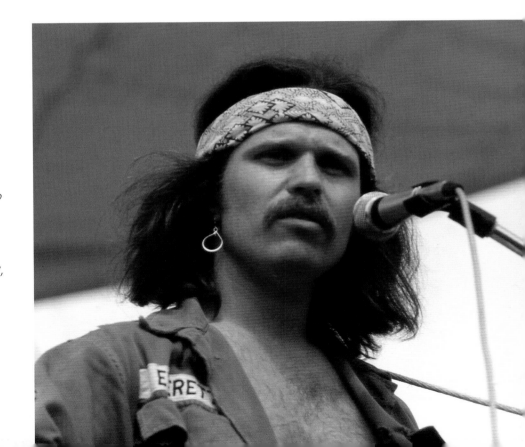

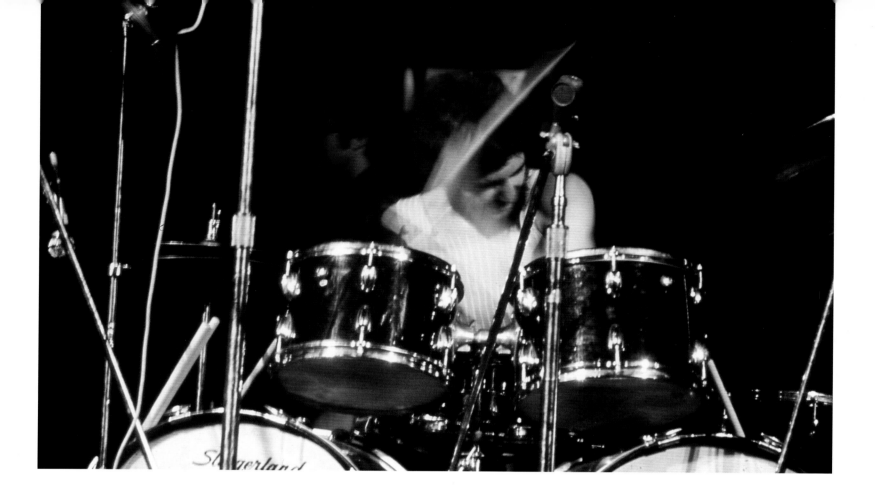

Canned Heat

The West Coast band called Canned Heat played a unique blend of blues and rock and appeared at Monterey Pop before Woodstock. After a helicopter dropped them off at Woodstock, they rocked the crowd with their version of "Goin' Up the Country." Though its members suffered from many feuds that seemed vital to amping up their performance, Canned Heat went on to tour successfully for decades, up to the present day.

Drummer, Adolfo de la Parra

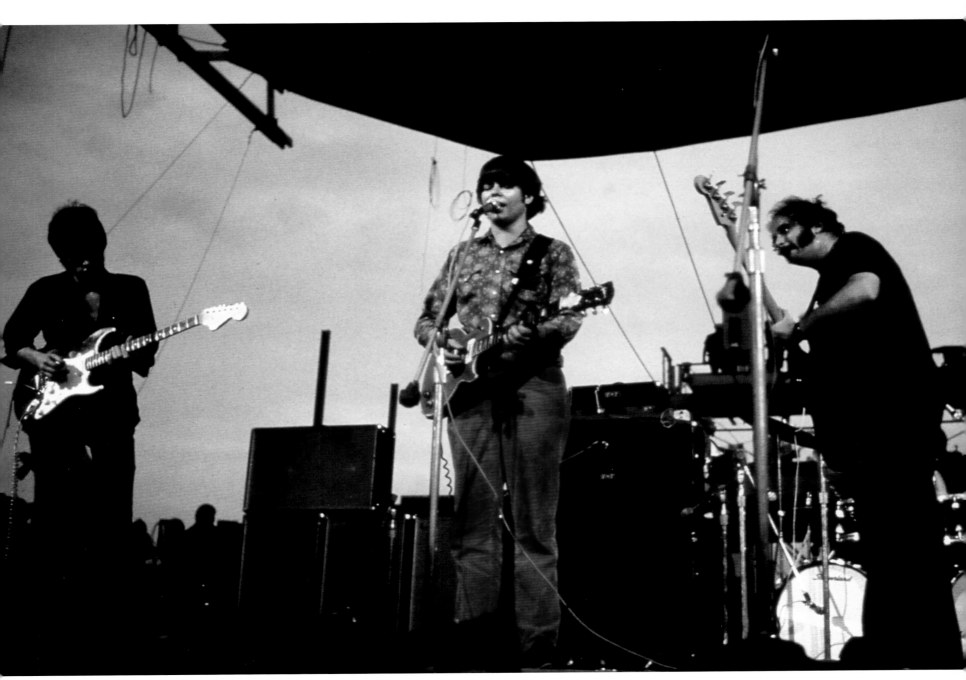

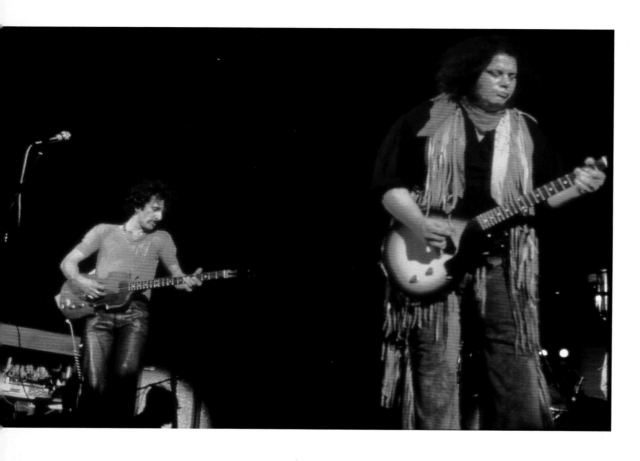

Mountain

With guitarist Felix Pappalardi at the helm, the heavy metal rock band Mountain landed with a considerable impact at Woodstock. Leslie West, the massive guitarist who also did vocals, described arriving by helicopter into an unreal scene. As far as he could see, there were little points of light on the hillside, made by myriad candles and lighters. They worked their way through a long set of nearly a dozen numbers, different than any that had been heard before at the Festival. Though it was just their fourth-ever live performance, they moved the music world to a heavier vibe.

Felix Pappalardi (left) and Leslie West

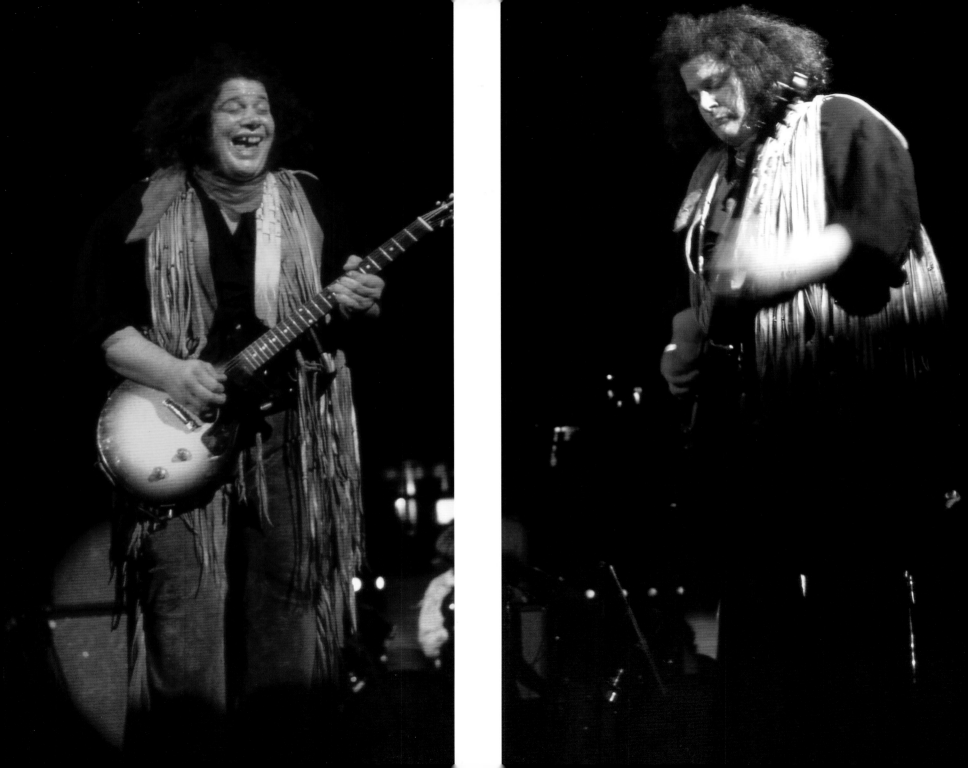

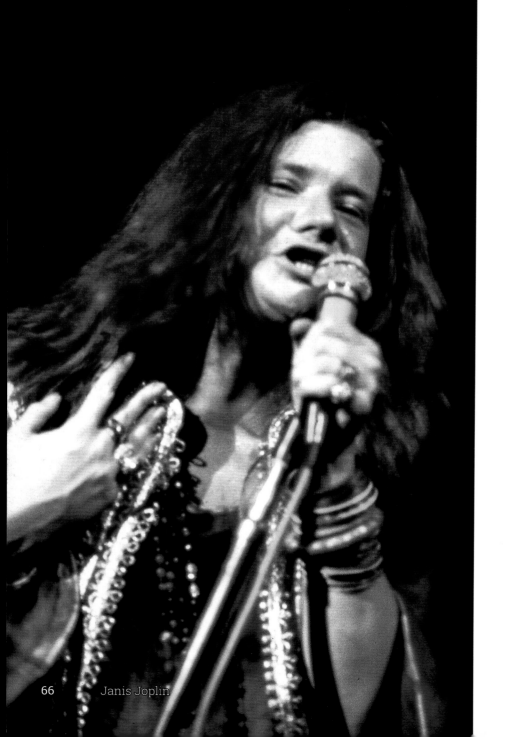
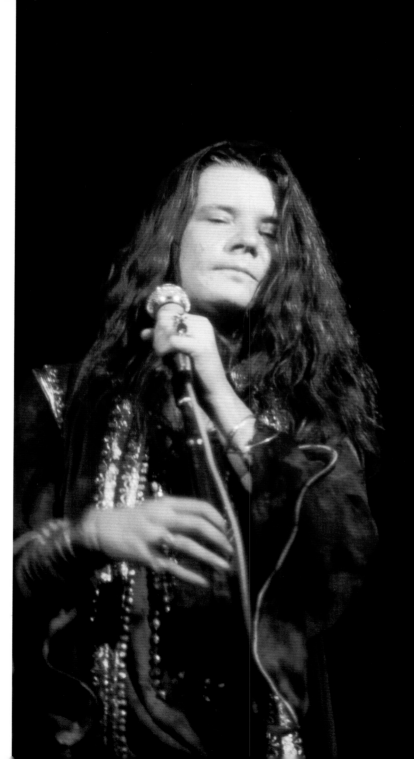

Janis Joplin

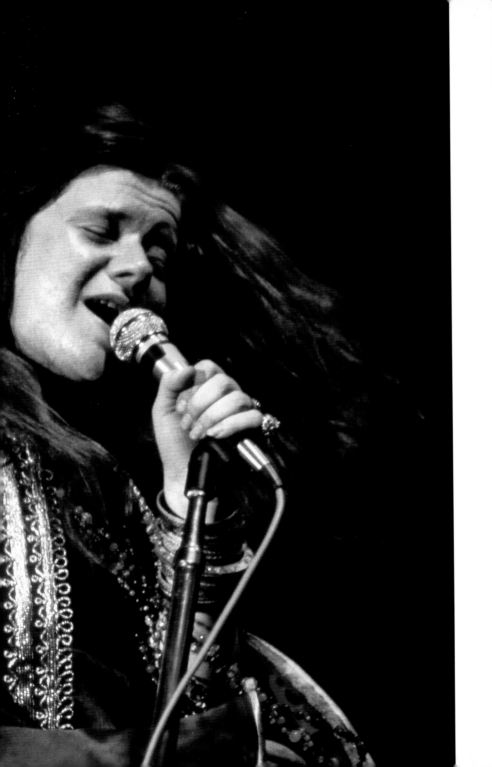
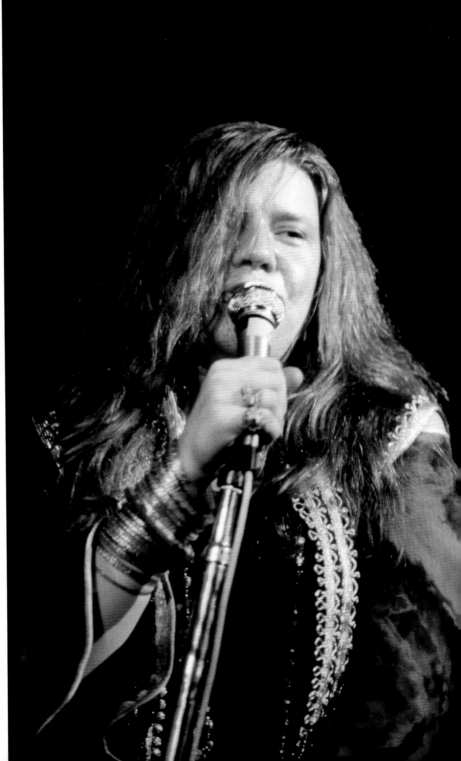

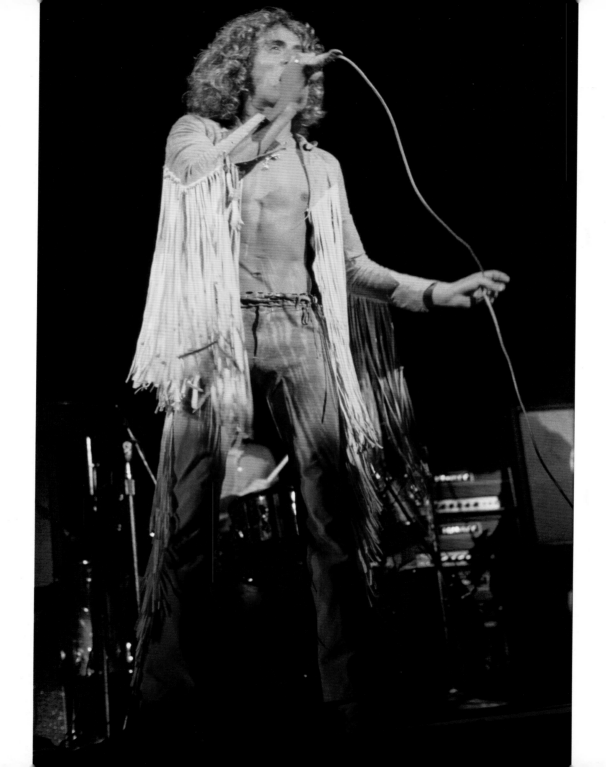

Roger Daltrey
of The Who

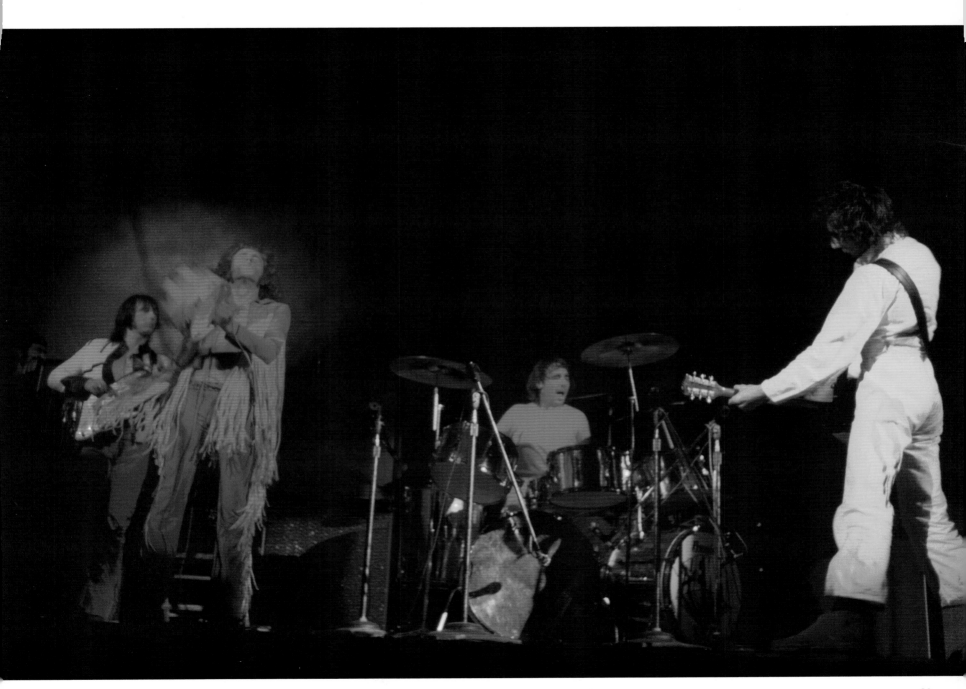

The Who

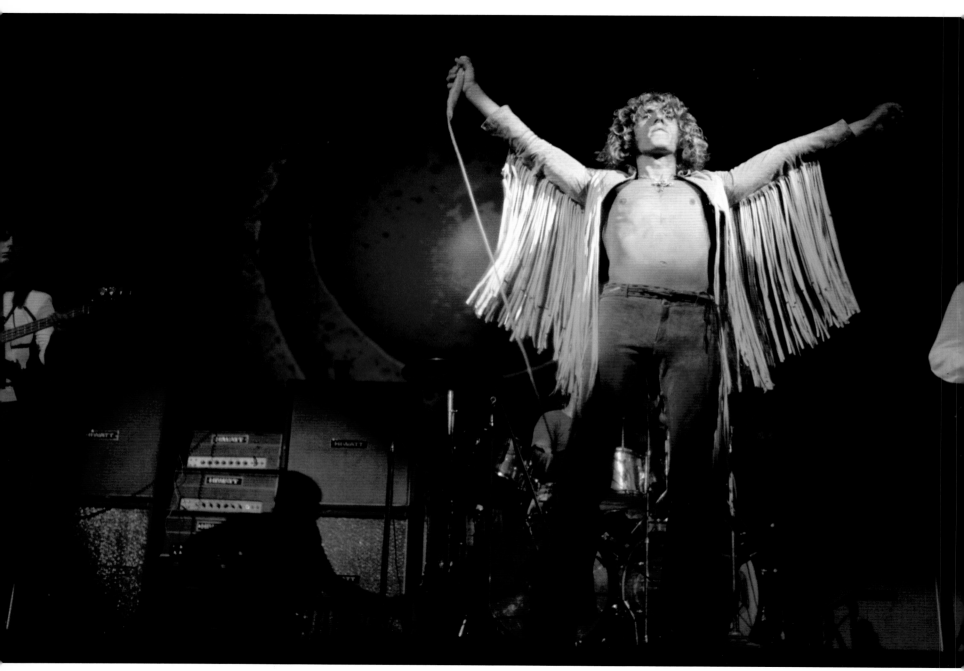

Roger Daltrey of The Who

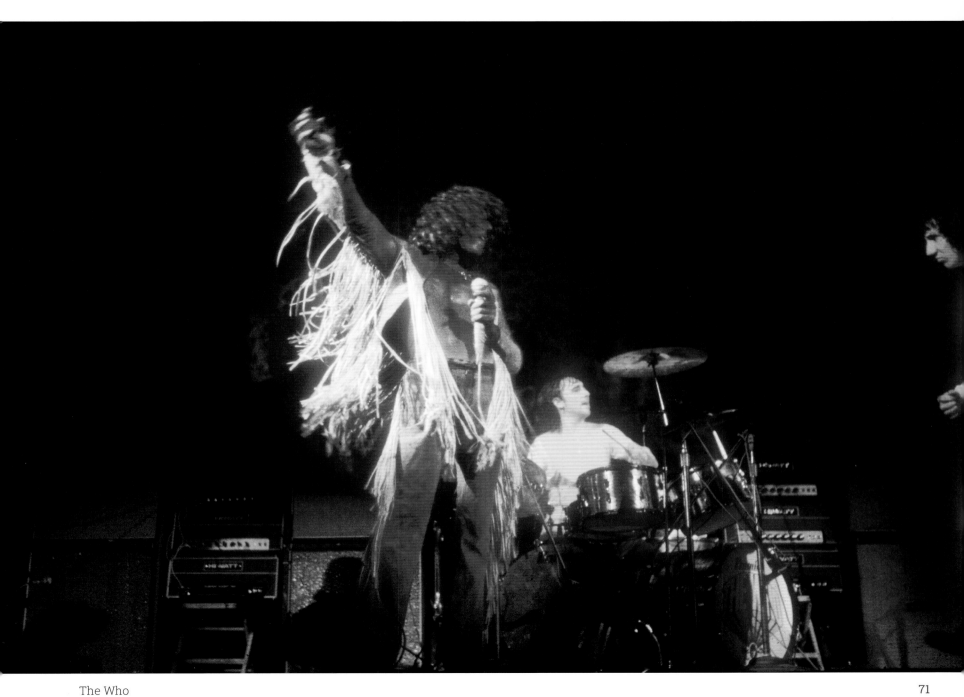

The Who

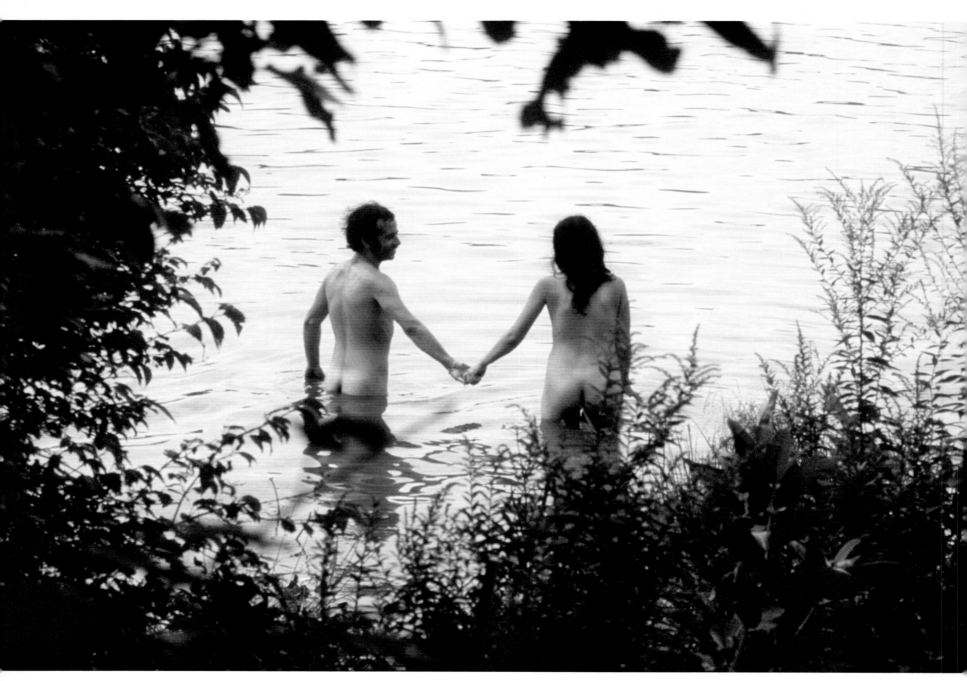

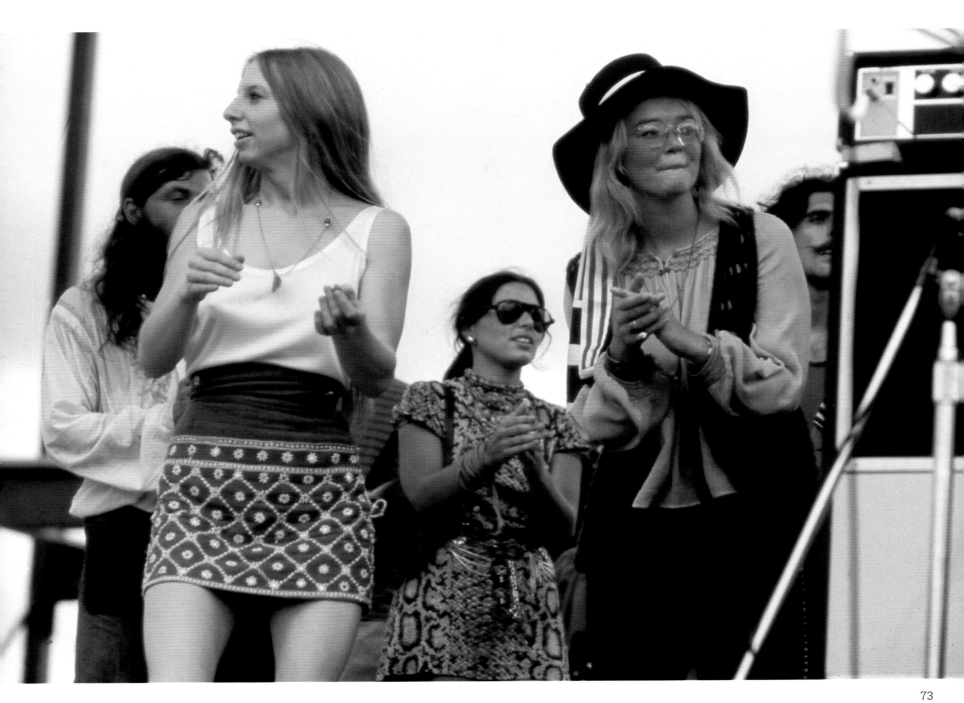

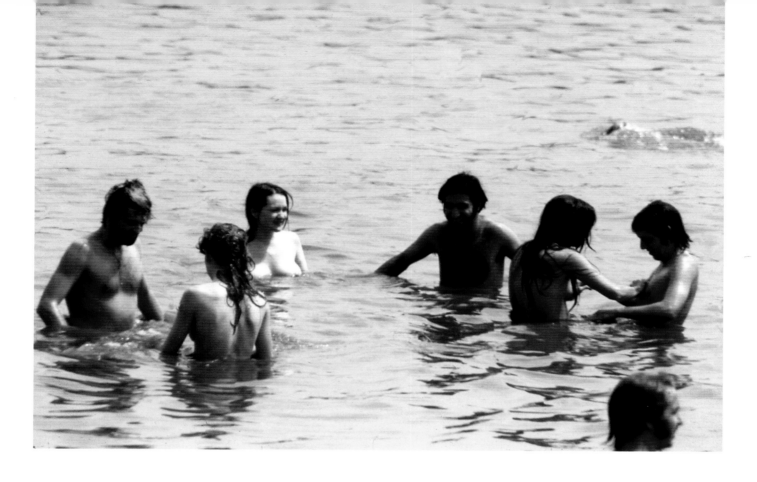

HIPPIES
←USE→
SIDE DOOR

TOWN OF WOODSTOCK MERCHANT CODE No. 1969

Though ironic, this souvenir sign expressed real feelings about young, long-haired people flooding into the town of Woodstock, New York.

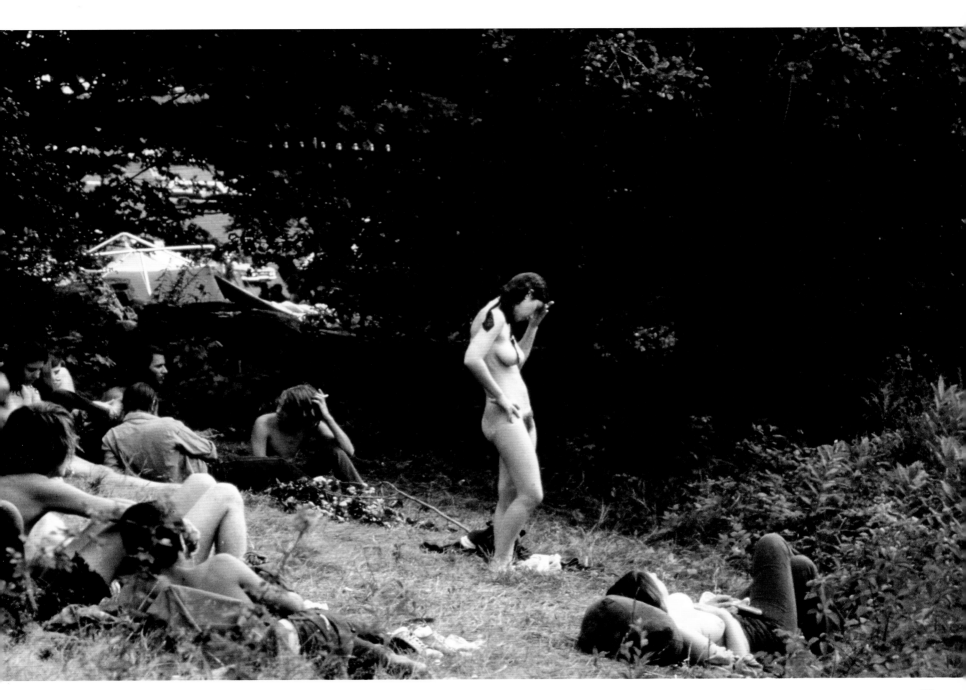

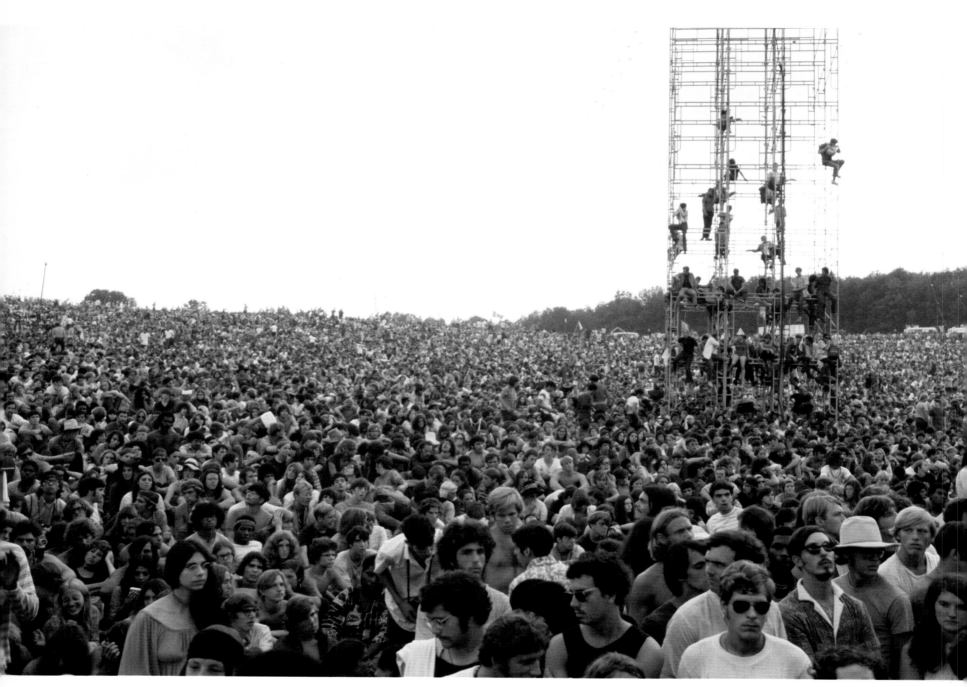

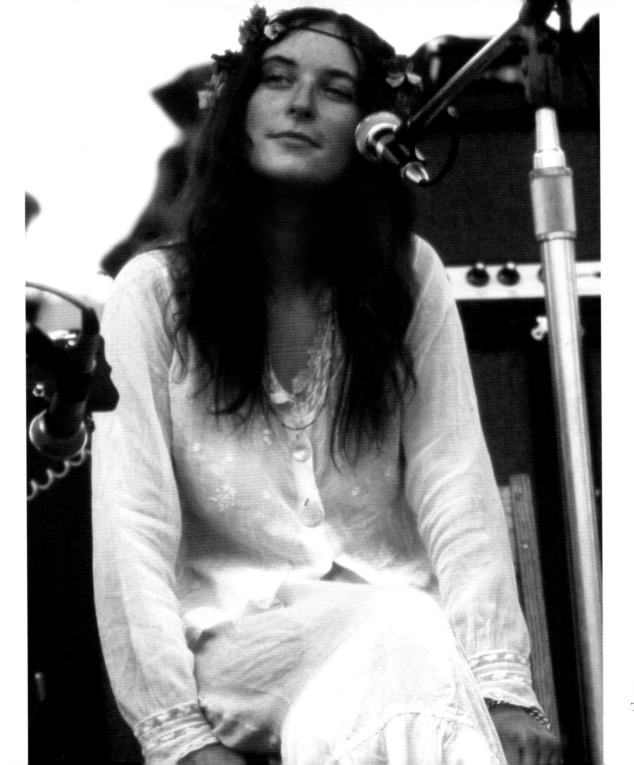

Christina
McKechnie of
The Incredible
String Band

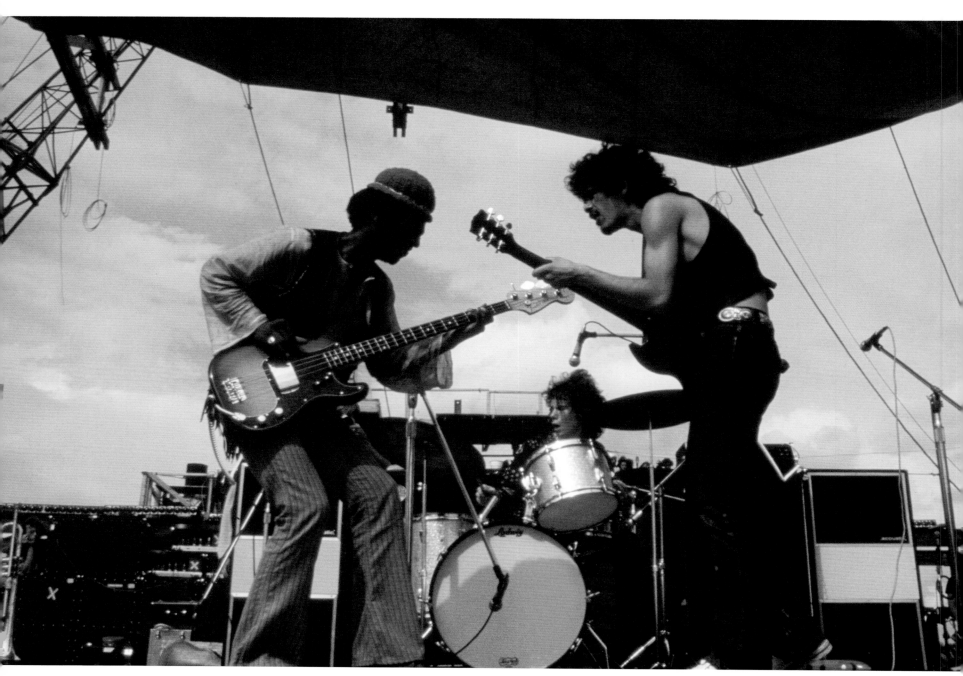

Santana, the Band, with Carlos Santana (right), David Brown (left), drummer Michael Shrieve

Michael Shrieve
of Santana

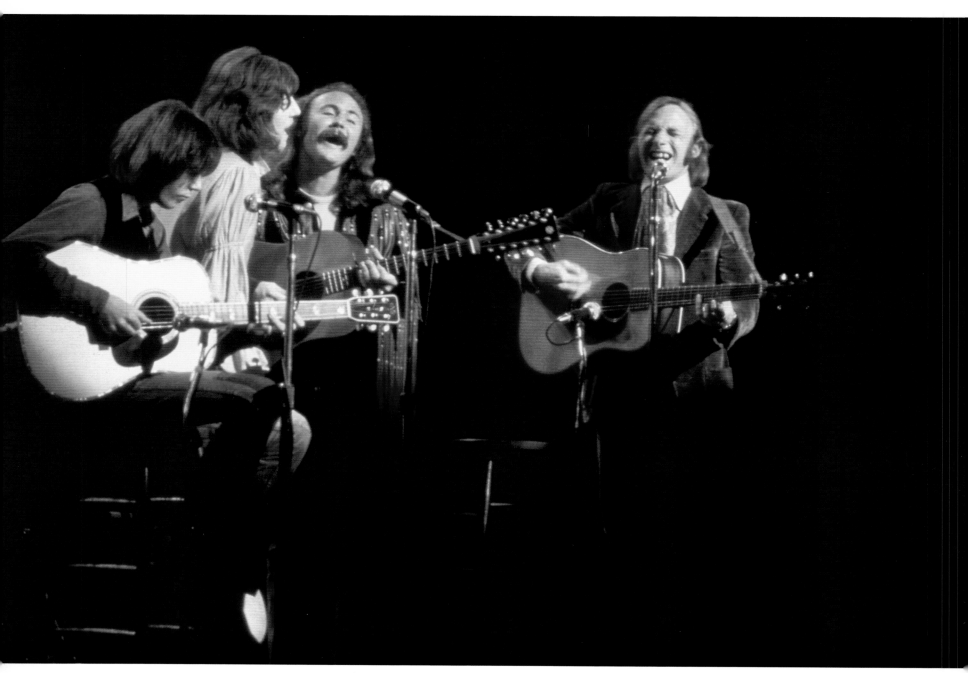

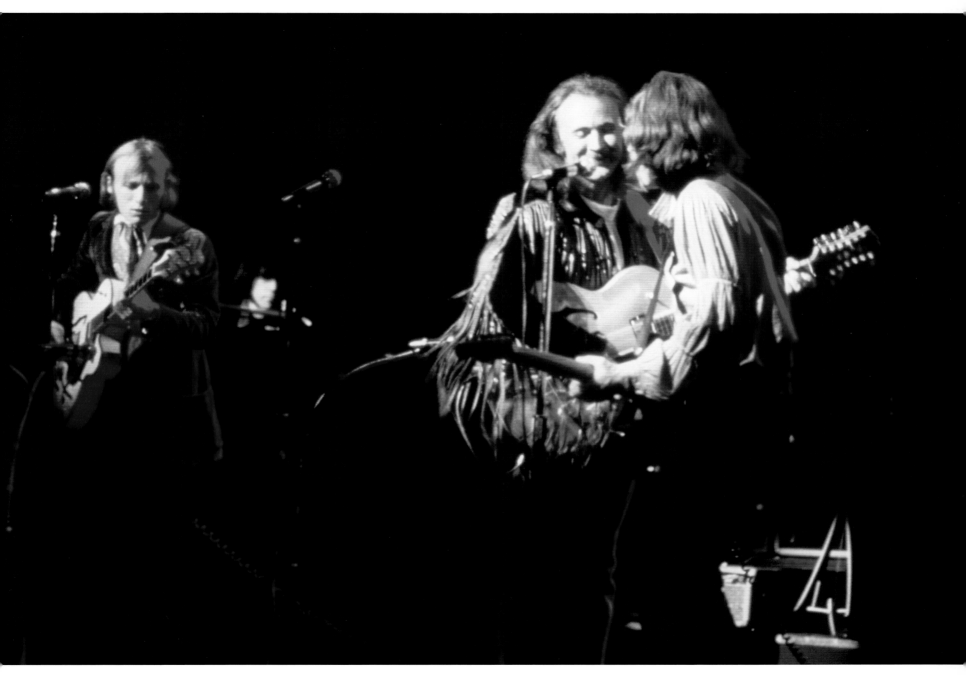

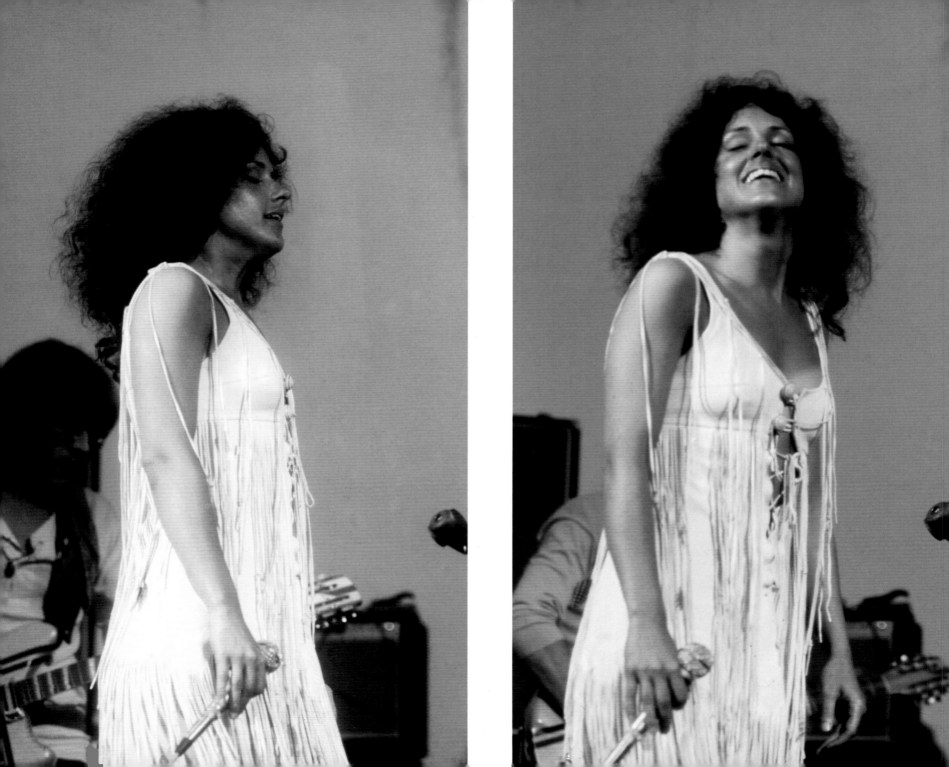

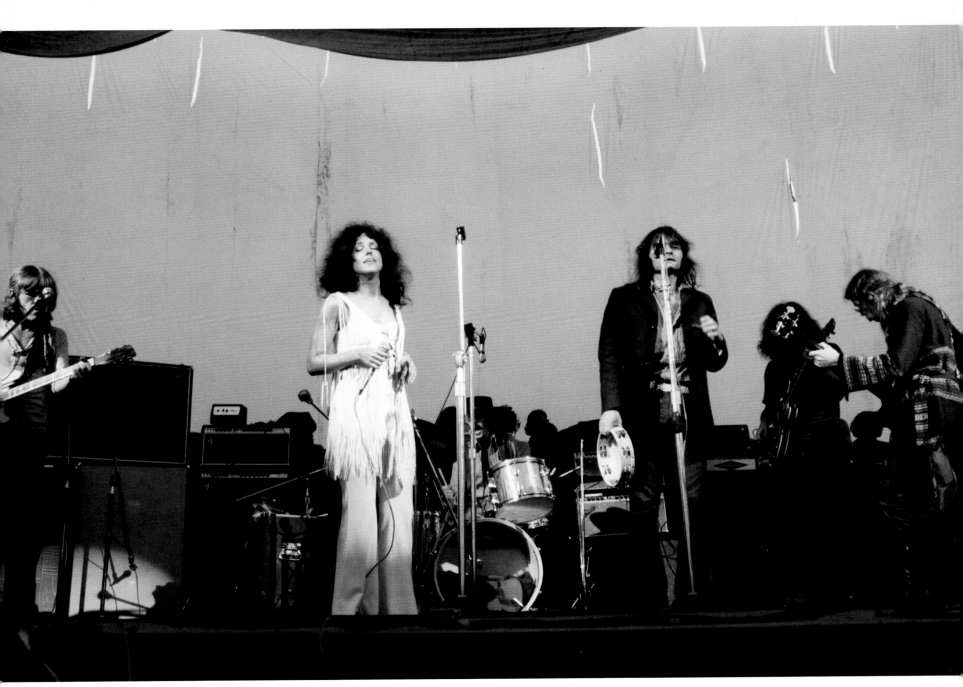

Grace Slick and Jefferson Airplane

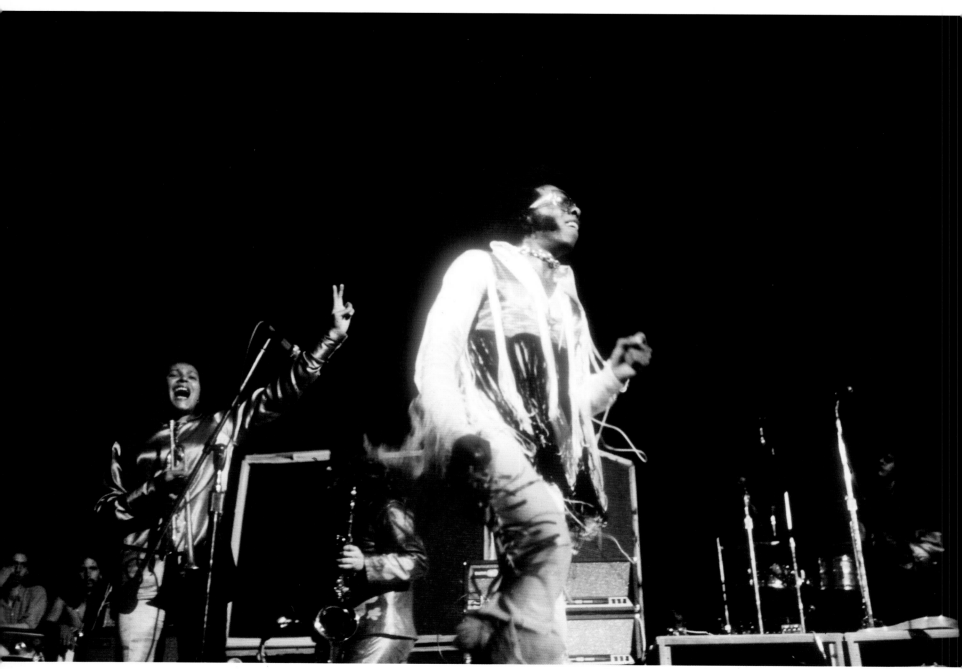

84 Sly and the Family Stone

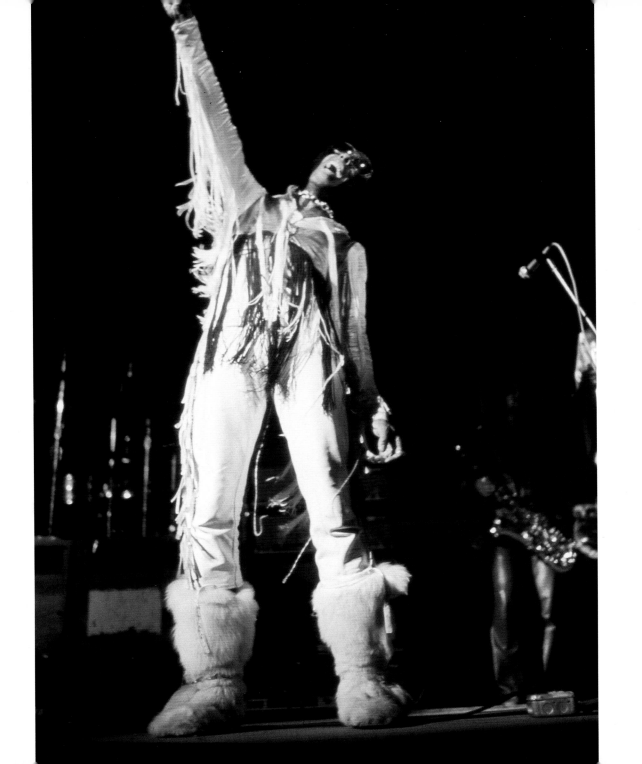

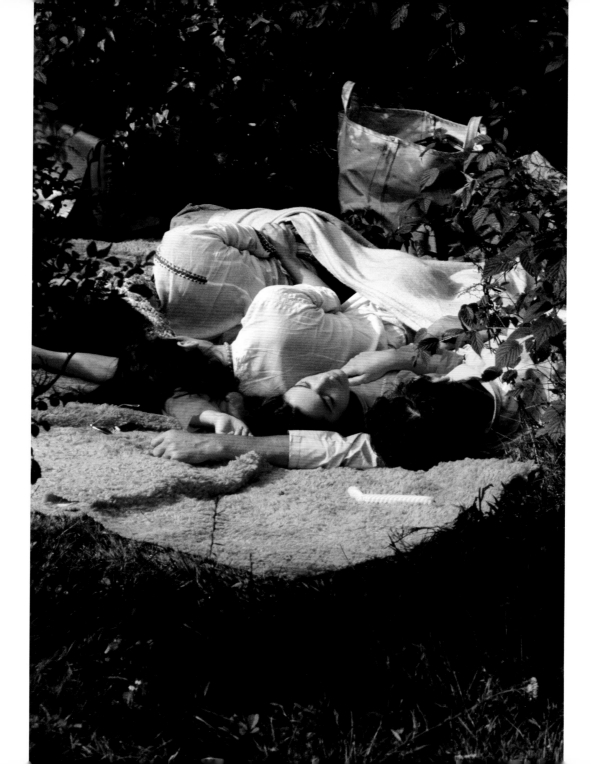

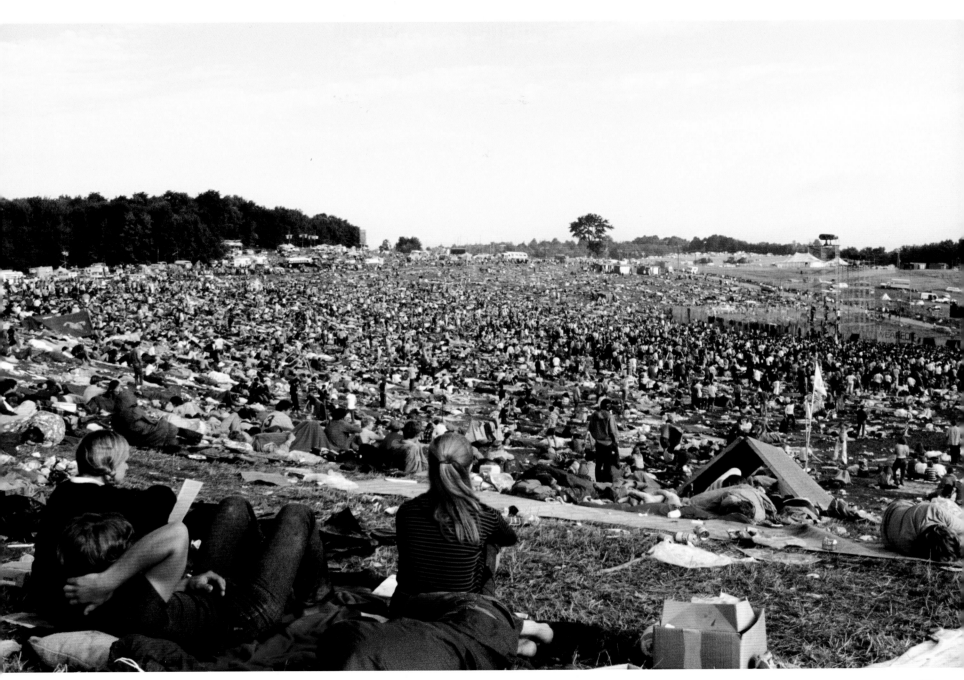

Last morning of the Woodstock Festival

Heading Home

Jimi Hendrix closed the Festival in the early morning of Monday, August 18, with an ecstatic virtuoso performance of "The Star Spangled Banner." Its notes could be heard floating across the festival site as the audience slowly made its way out of Bethel.

When it was over, and the vast crowd finally dispersed, when the festival site was cleared of the trash and mud, something tangible came out of it. Many found themselves profoundly changed by the experience. Would-be lawyers became craft jewelers, accountants turned to making tie-dyed clothing, the straightest of students sought a different path. The goal, many discovered, was not to make money but to live a good life. Woodstock stood as a message of peace and hope.

For Alan Revere, a recent college graduate who was headed for law school, the experience completely changed his life's direction. Before arriving at Woodstock, he said, "My life was swinging around like a compass needle. Woodstock was the lodestone. The energy was cyclonic. It was at Woodstock that I decided to abandon law school in order to pursue art and become an artist.

"In retrospect," he said, "my decision was the logical product of the external and internal revolution we were all going through, a rejection of the establishment and anything tied to it." More than that, he said, lawyers represented something that people were obliged to pay for, but nobody had to pay for art unless they chose to do so. "Art represents a higher level of compensation where the payment is a true gift of appreciation." He and his friends left Max Yasgur's farm, he said, "and drove another twenty miles until we found the end of the cars parked along the road. And then the highway opened up before us."

For Revere, as for many others, the highway led to a life that was becoming known as the counterculture. Maybe they were thinking about their parents' lives, working at the same tedious job for thirty years. Perhaps they realized that there was a big, exciting world out there, waiting to be explored.

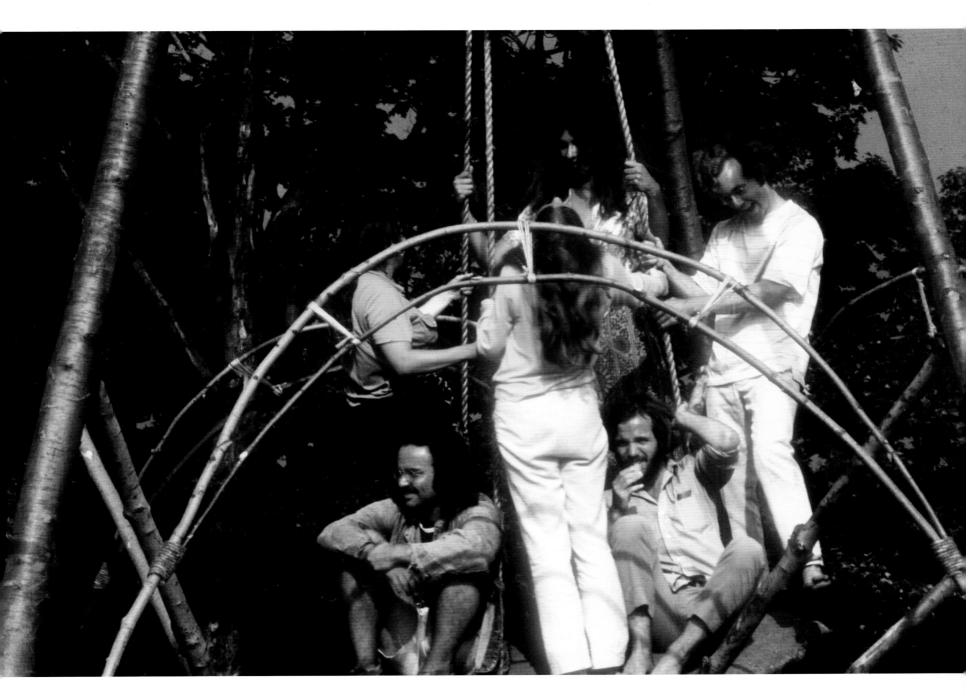

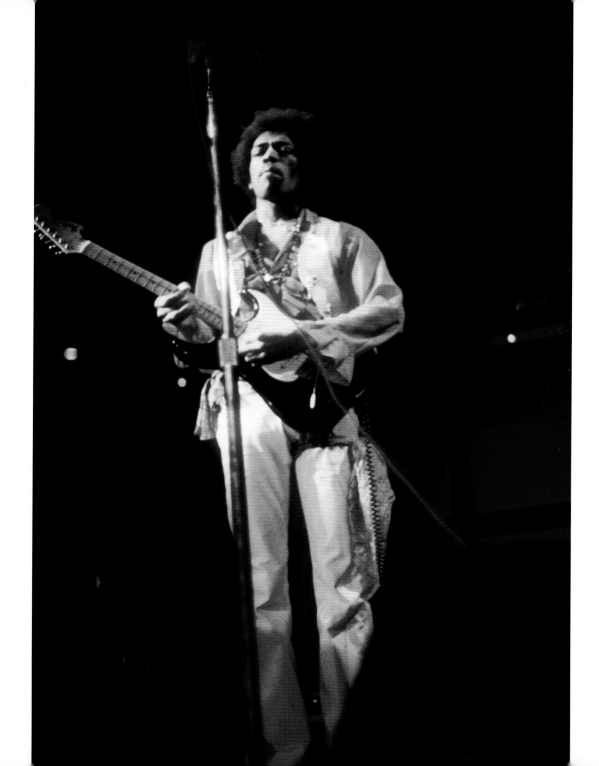

Jimi Hendrix

CHAPTER FIVE

Fillmore East

The stunning variety and brilliance of the bands that appeared at Woodstock continued at the Fillmore East in New York City's East Village. This off-the-beaten-path neighborhood with its downtown vibe was the perfect scene for the talent and energy of the acts that performed there during its three glorious years of existence. Entrepreneur Bill Graham managed to attract every name imaginable, from The Who to Jefferson Airplane, from Janis Joplin to Jimi Hendrix.

The light shows that accompanied the musicians created the perfect atmosphere, and the small size of the auditorium made for an intimate and enchanting place for devoted fans to see their favorite artists and experience new ones as well, all at an affordable price.

Jimi Hendrix was the perfect musician for that venue. He was outsized in his gestures and his brilliant, colorful outfits, but it was his electrifying guitar-playing that captivated the audience. With the light show adding its magic, Hendrix dazzled in his sets at the Fillmore East.

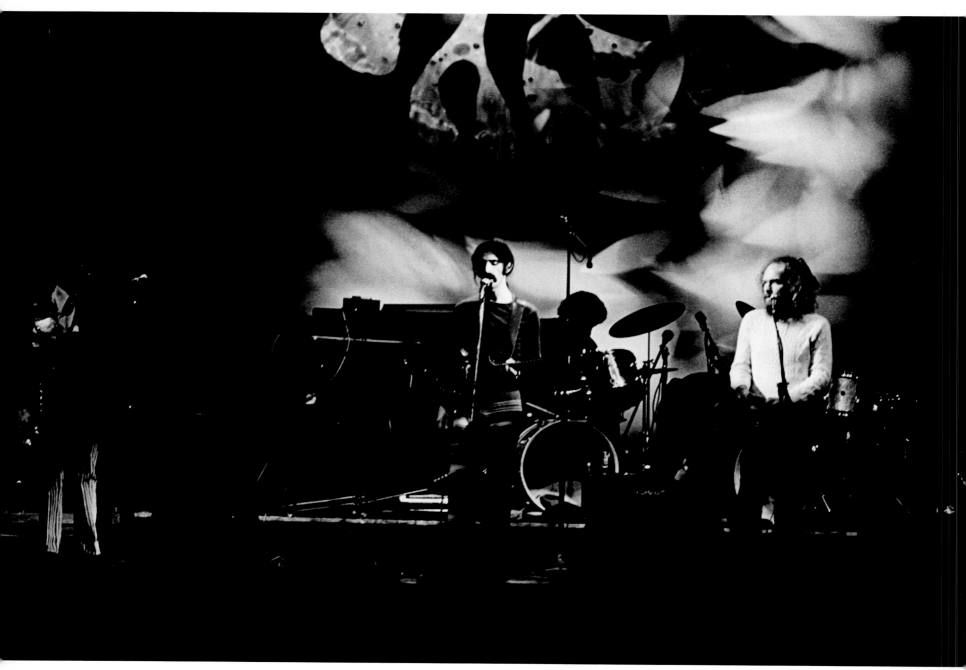

Frank Zappa and The Mothers of Invention, with Joshua Light Show

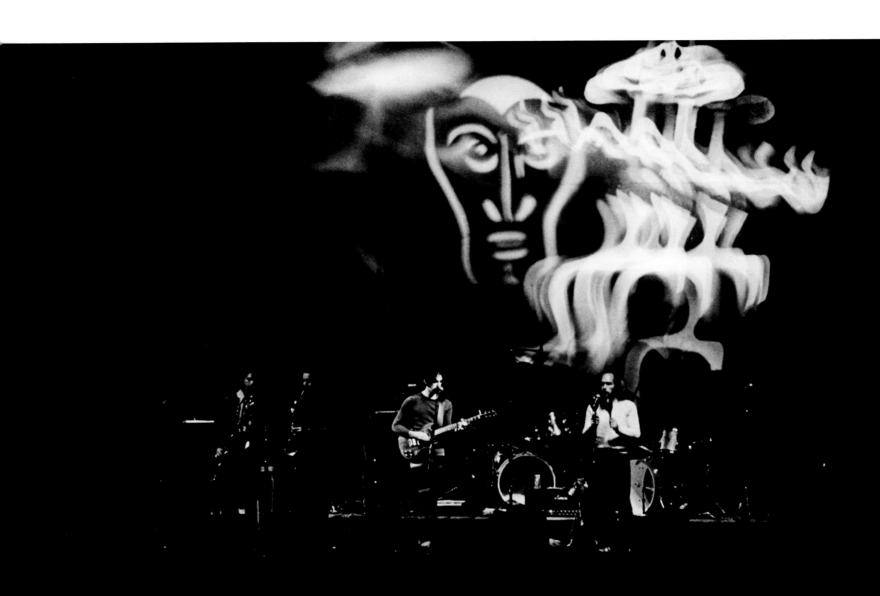

Ultimately it was the low ticket prices that did in the Fillmore East. Between overhead for the theater and fees for the acts, Graham was forced to close the Fillmore East in 1971. Today, all that's left of it is a small bronze plaque marking the site where it once stood. The neighborhood has gentrified to the point where million-dollar apartments have nearly obliterated the shops selling beads, smoking paraphernalia, and pseudo-hippie clothing.

Jim Morrison of The Doors

One of the most charismatic musicians of the era, Jim Morrison, burned very brightly and briefly. He was lead singer for The Doors and left behind a collection of poetry that often spoke of the ephemeral quality of life. His poems often intimated that death was near, which proved to be true for him. He died in Paris in 1971 at the age of twenty-seven; the cause of death was never determined conclusively.

Site of the Fillmore East (1968-1971)

Fans of live rock, folk, and blues music streamed through this entrance during the brief but memorable life of the Fillmore East. The great concert promoter Bill Graham brought The Who, Jimi Hendrix, Janis Joplin, the Grateful Dead, and many more into a concert hall beloved by artists and audiences alike for its intimacy, acoustics, and psychedelic light shows.

Placed by the Greenwich Village Society for Historic Preservation with the generous support of the Two Boots Foundation

His music has become the sound track for the era, often underscoring themes in movies including the powerful anti-war film, *Apocalypse Now*. A biopic about his life called *The Doors* was released in 1991 and featured Val Kilmer in a remarkably successful evocation of Morrison's style and appeal.

Although Jim Morrison and The Doors performed at the Fillmore East, these photos were taken at the Felt Forum in New York City on January 17, 1970.

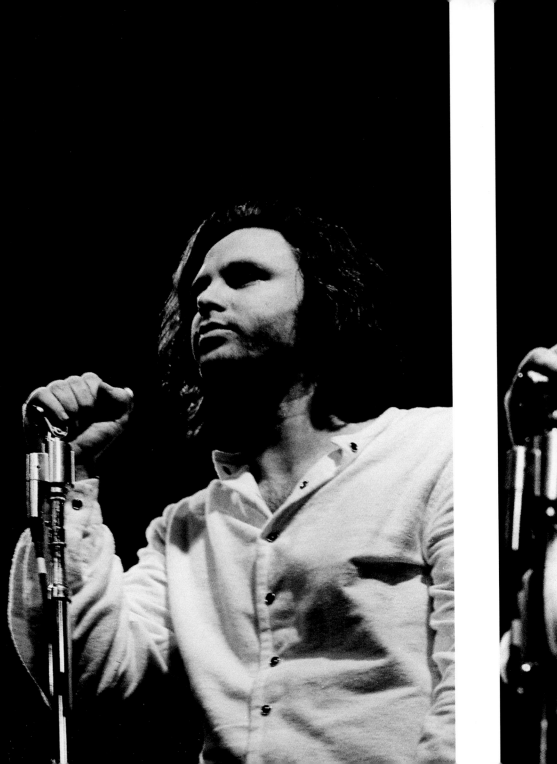
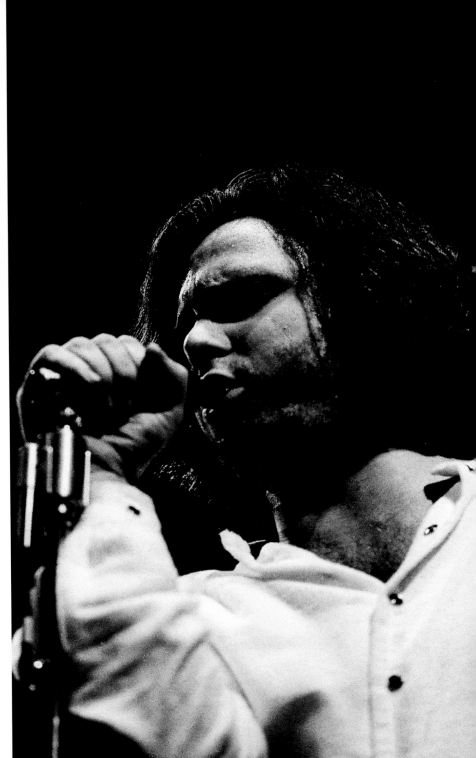

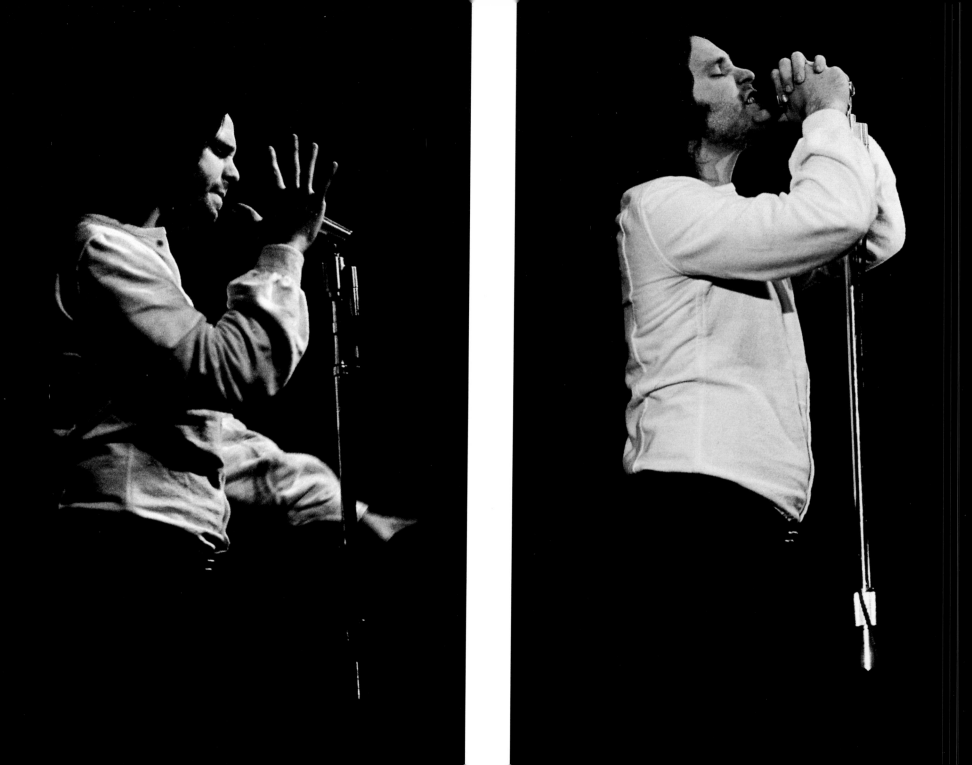

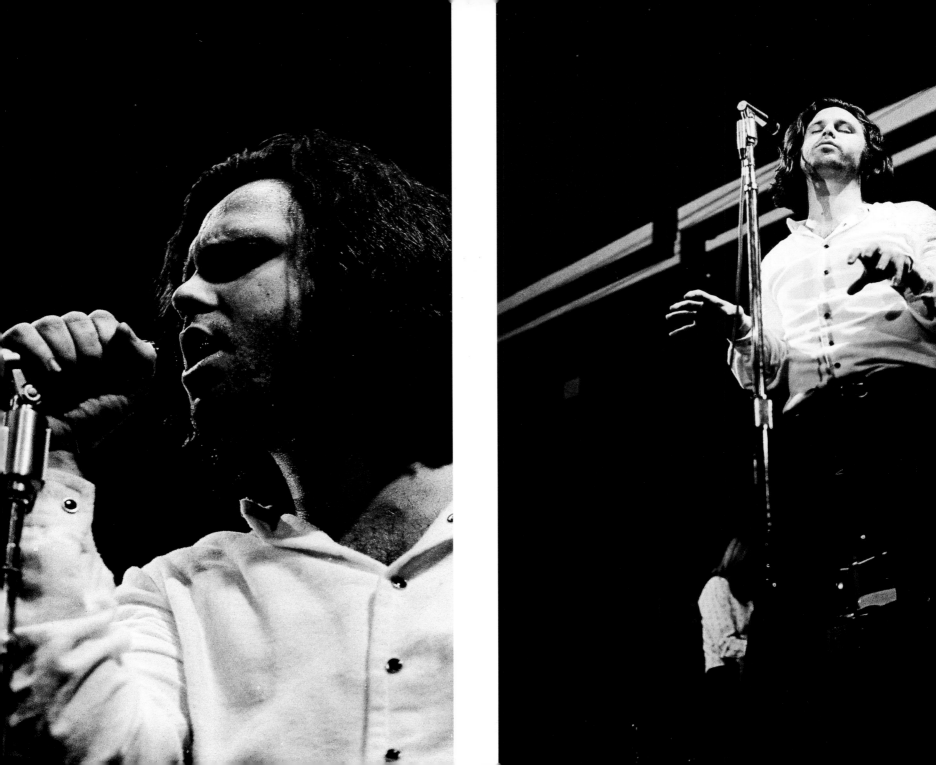

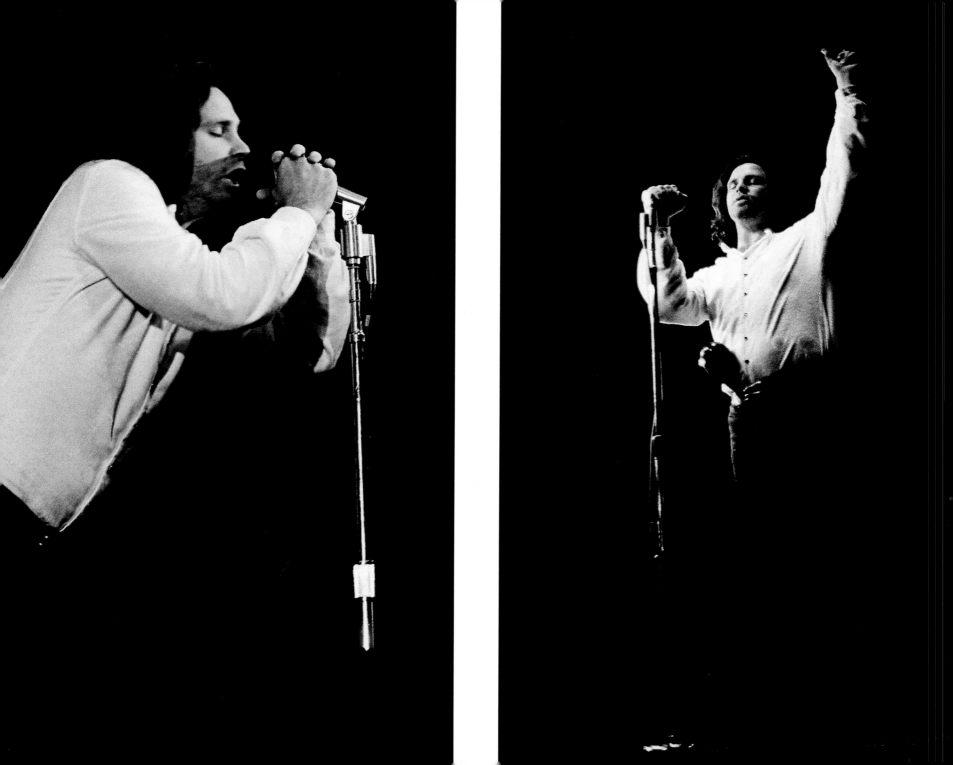

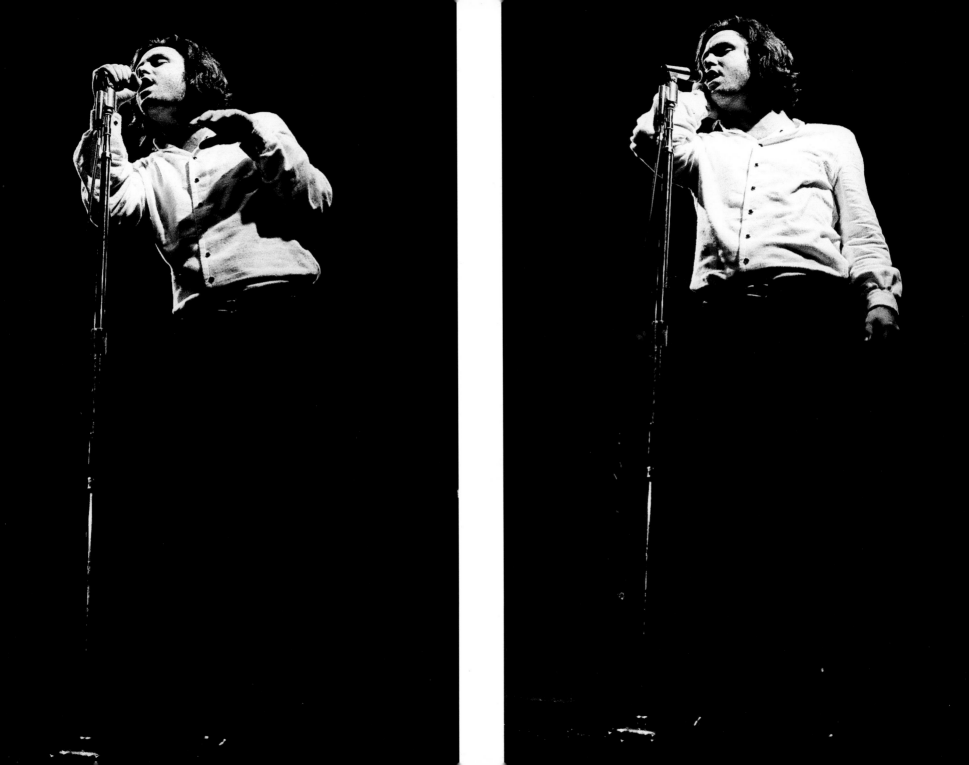

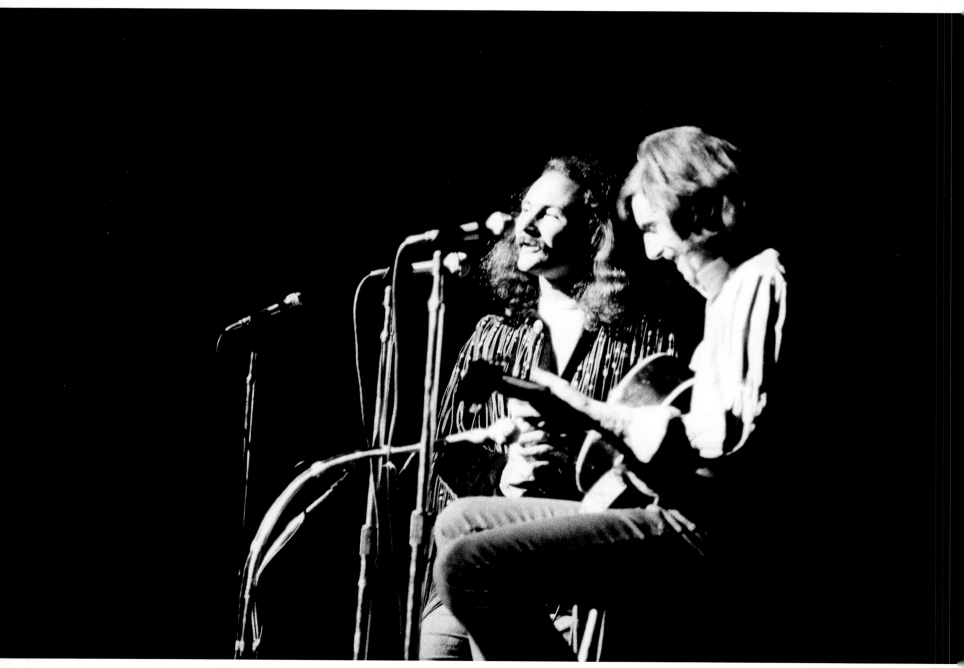

Crosby, Stills, Nash & Young

Though many of the bands that played at Woodstock, or anywhere for that matter, tended to have a shifting group of musicians, Crosby, Stills, Nash & Young were unique in becoming a foursome shortly before their performance at Woodstock and then largely going their own ways. Woodstock was only their second performance as a band, and appearing before that stupendous crowd terrified them. It wasn't only the crowd that overwhelmed the group, but rather the realization that the most famous acts of the time were right there on the same stage. The band played with a rotating cast of musicians at the Fillmore East and elsewhere. Ironically, one of their most successful songs was a cover of Joni Mitchell's song, "Woodstock," which she wrote while holed up in a hotel room, watching news reports of the event. On the advice of her manager, she declined the chance to go to the Woodstock Festival, appearing instead on the Dick Cavett TV show.

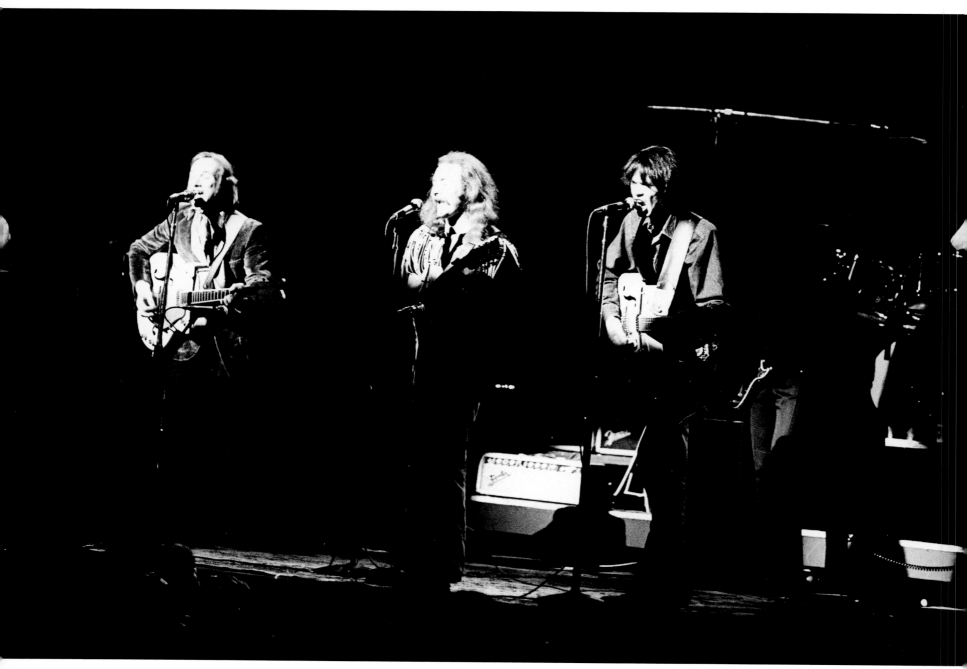

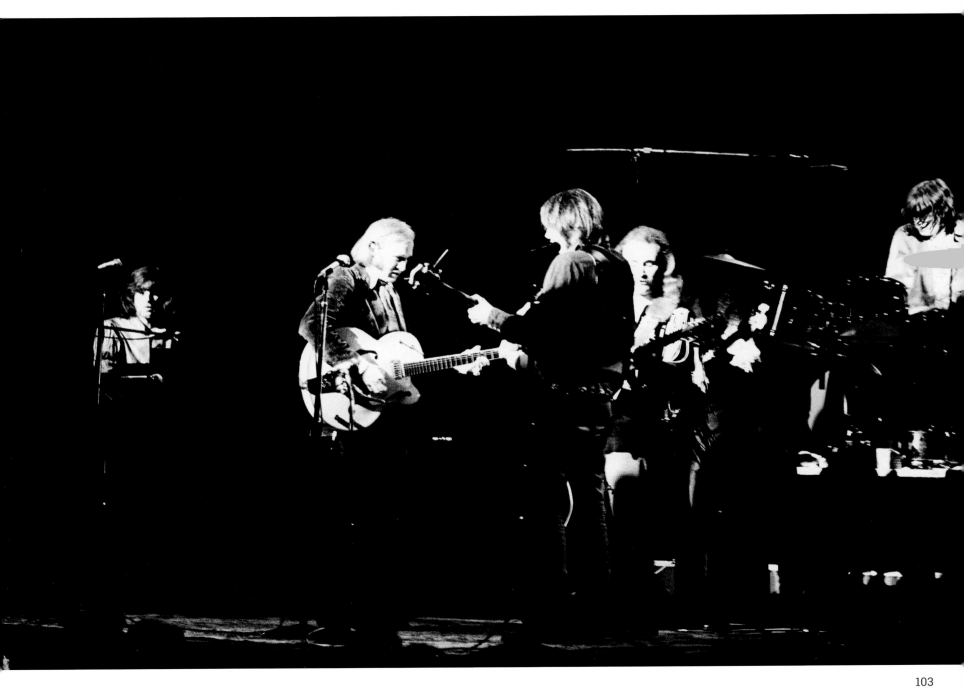

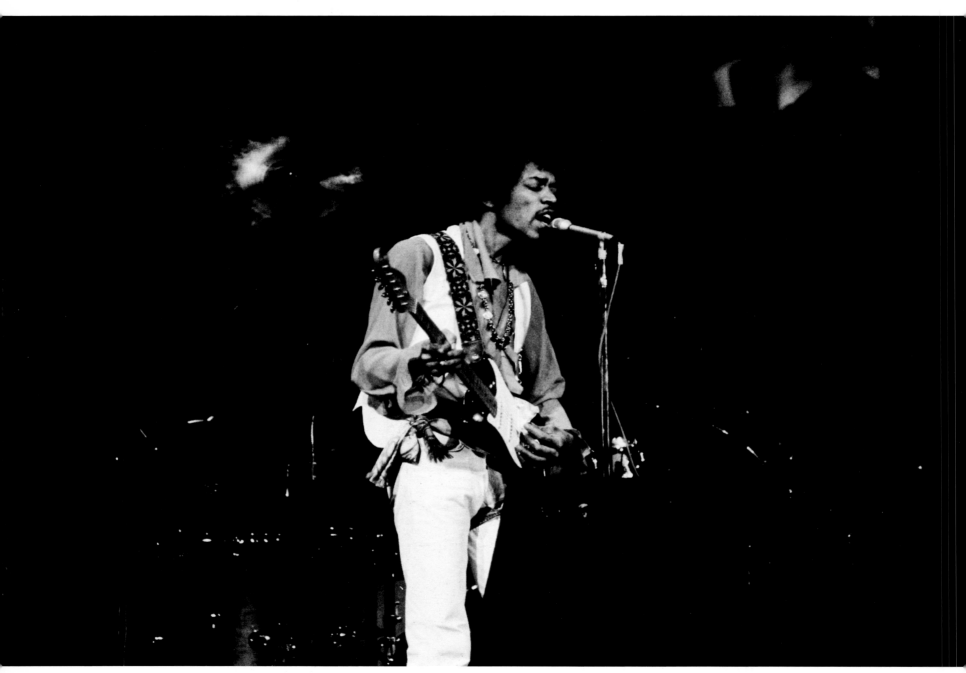

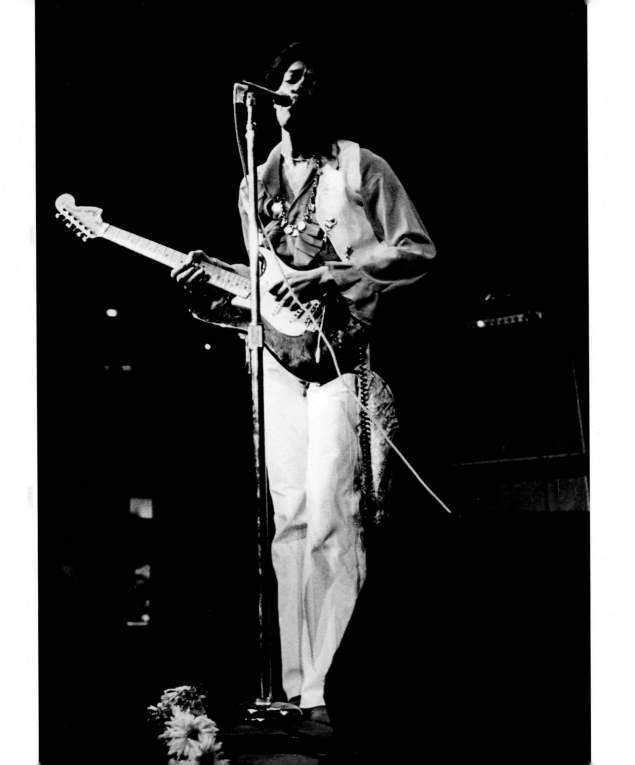

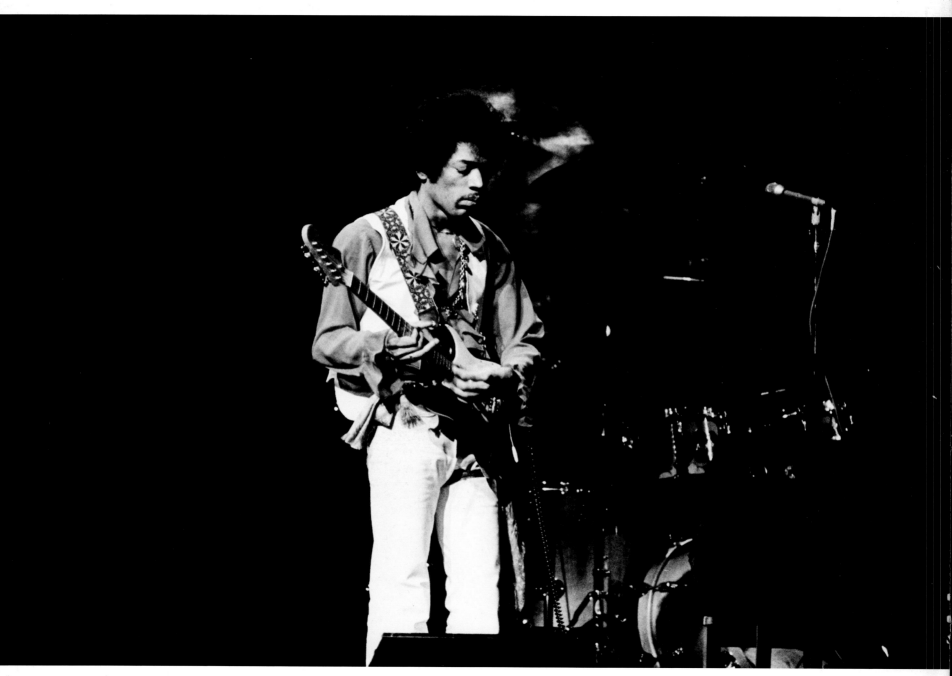

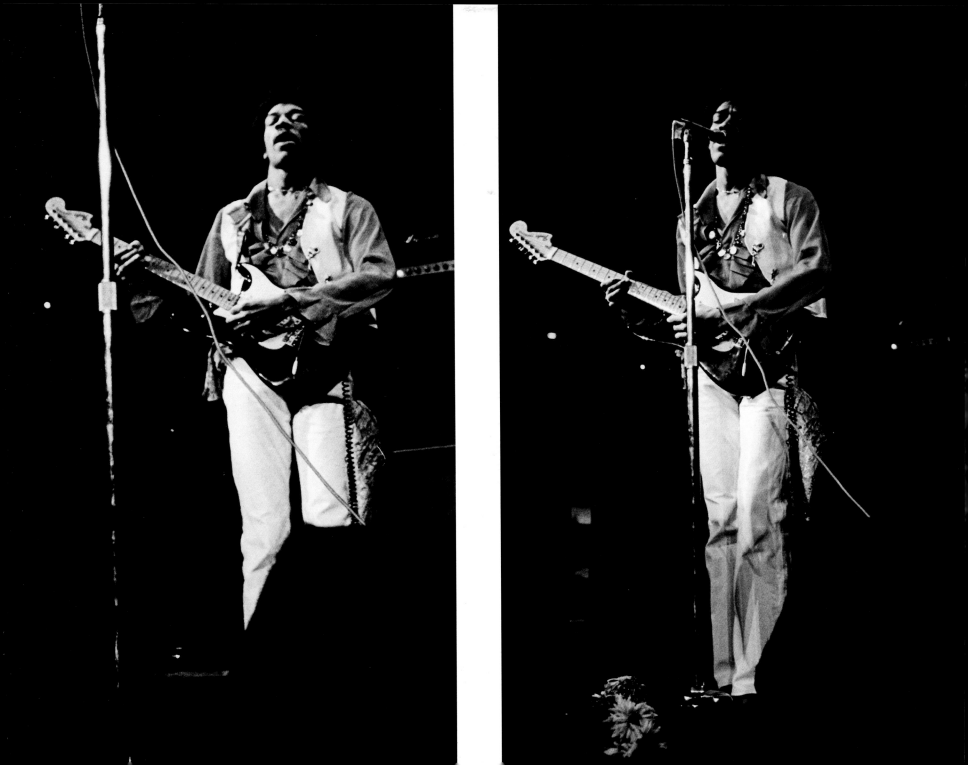

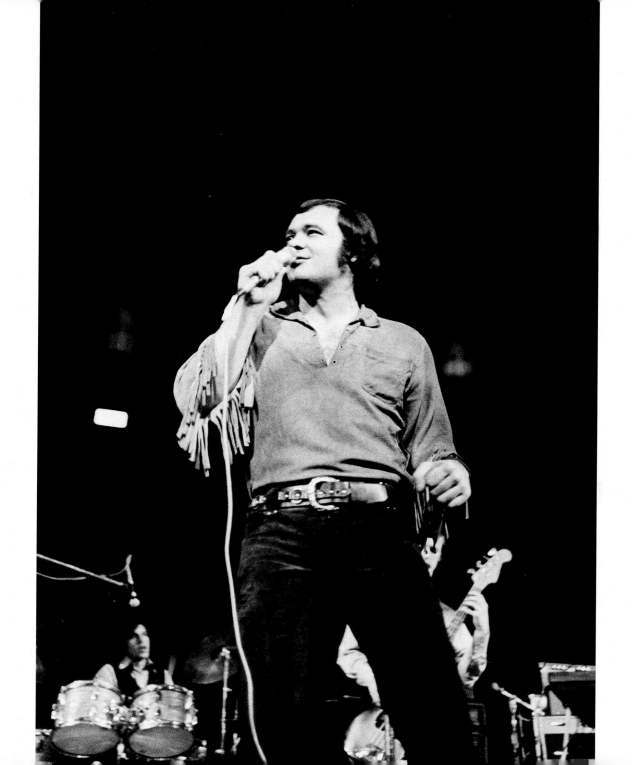

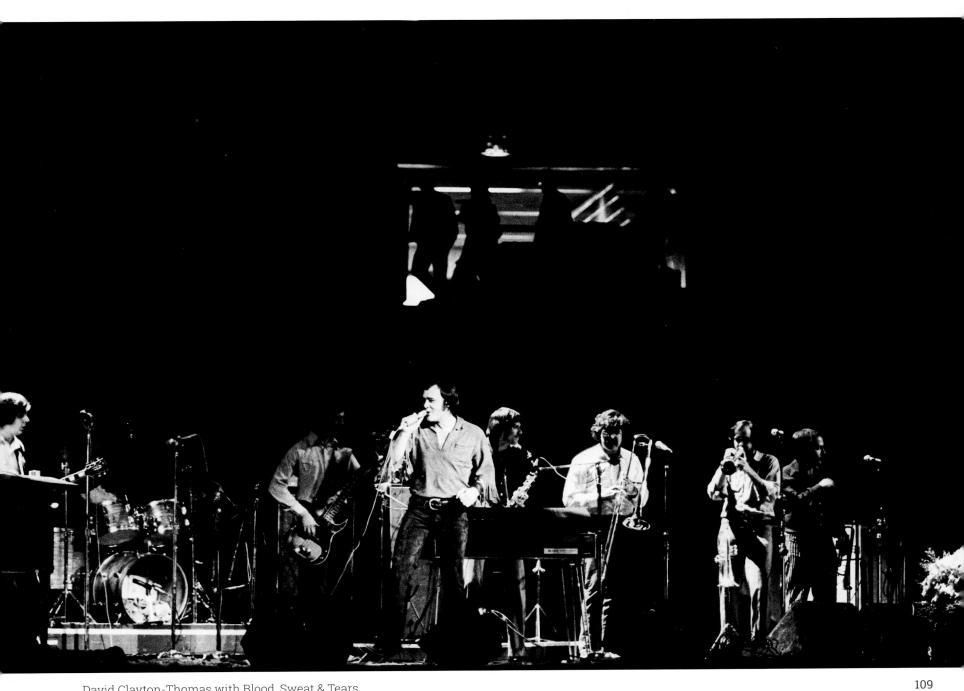

David Clayton-Thomas with Blood, Sweat & Tears

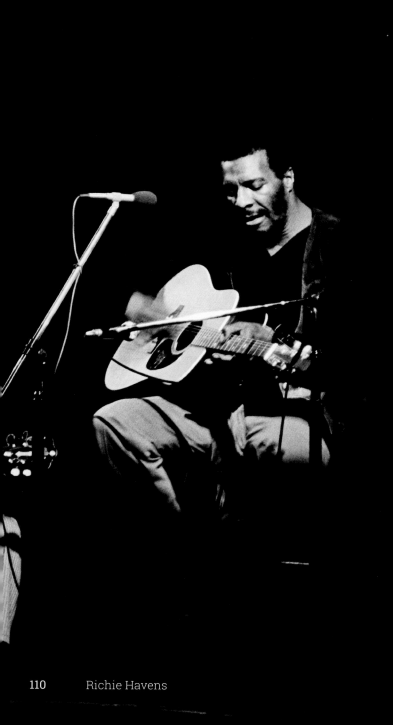
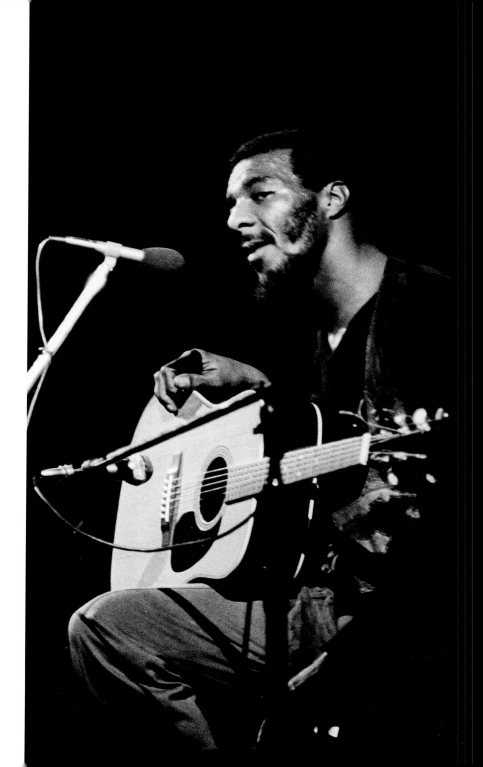

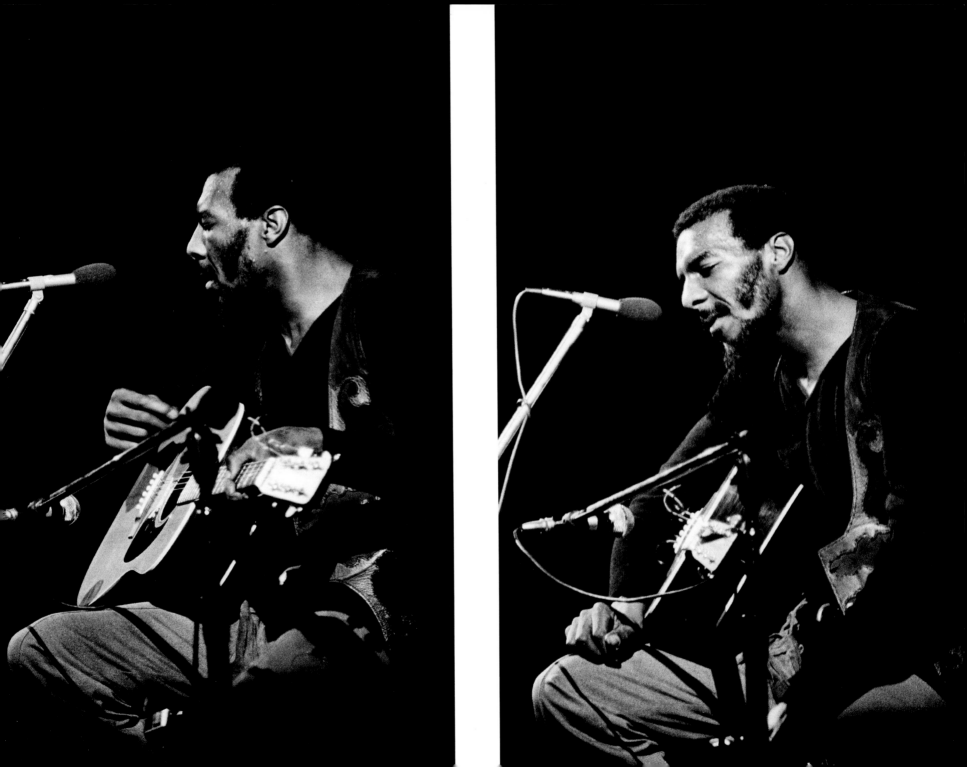

Greenwich Village

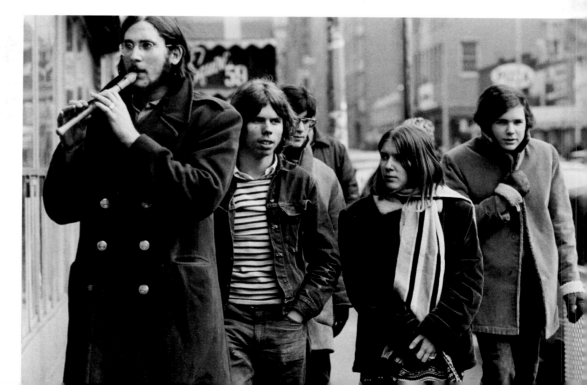

BILL GRAHAM'S
FILLMORE EAST

11 12 JANIS JOPLIN-GRATEFUL DEAD
14 15 JEFF BECK - WINTER
21 22 MOTHERS - BUDDY MILES
23 LORIN HOLLANDER

In the late 1960s, Greenwich Village in New York City was "the" gathering place for musicians and young people seeking a less conventional way of life. Jimi Hendrix launched his career at Cafe Wha?, one of the clubs that has survived for more than fifty years. Bob Dylan was performing at the Bitter End on Bleecker Street.

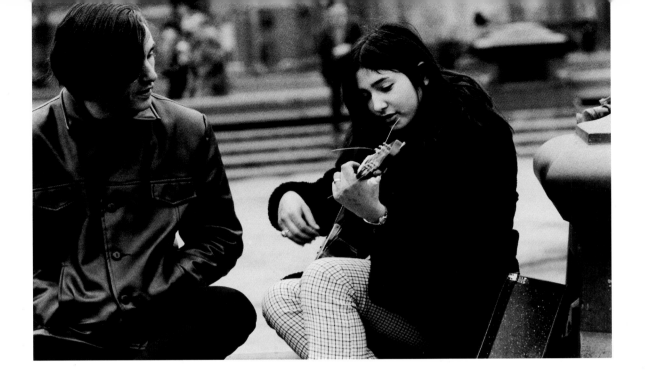

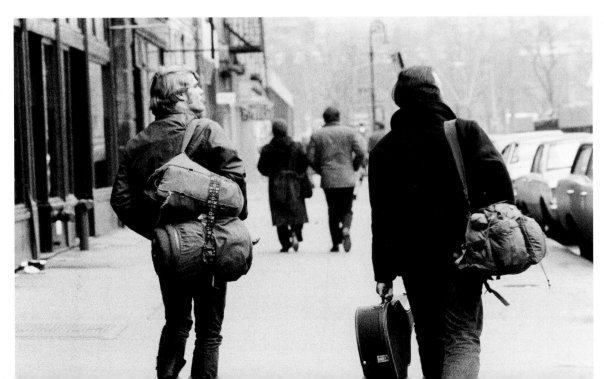

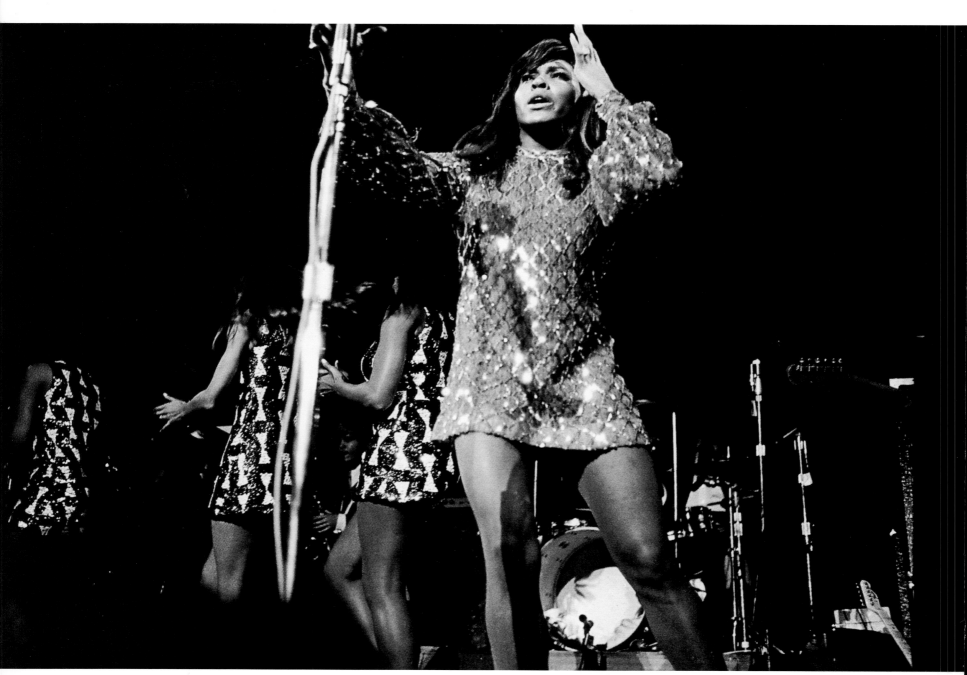

116 Tina Turner and her backup singers, The Ikettes

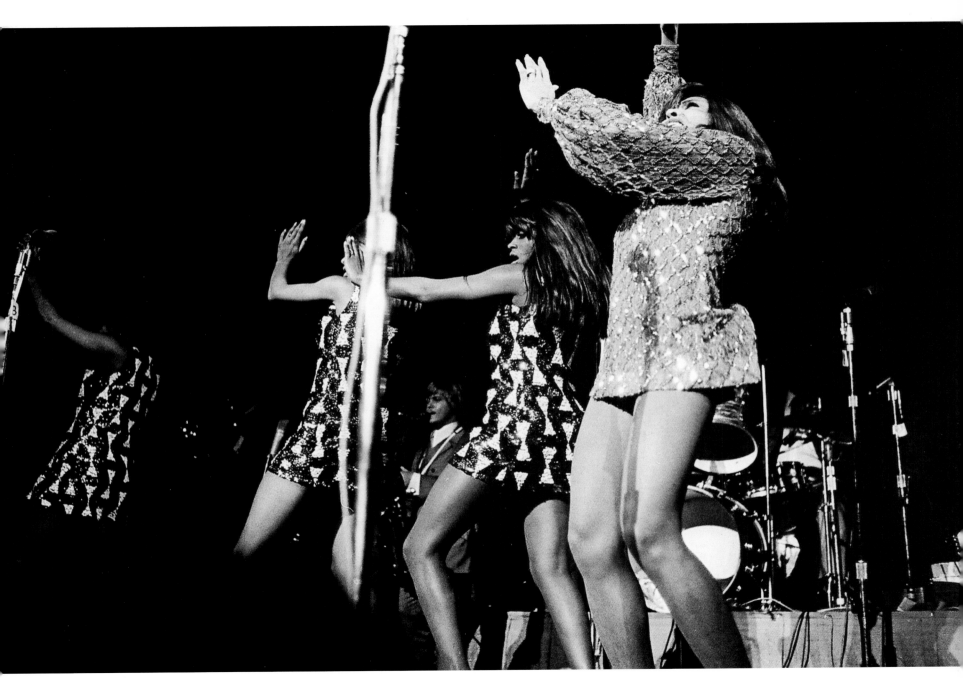

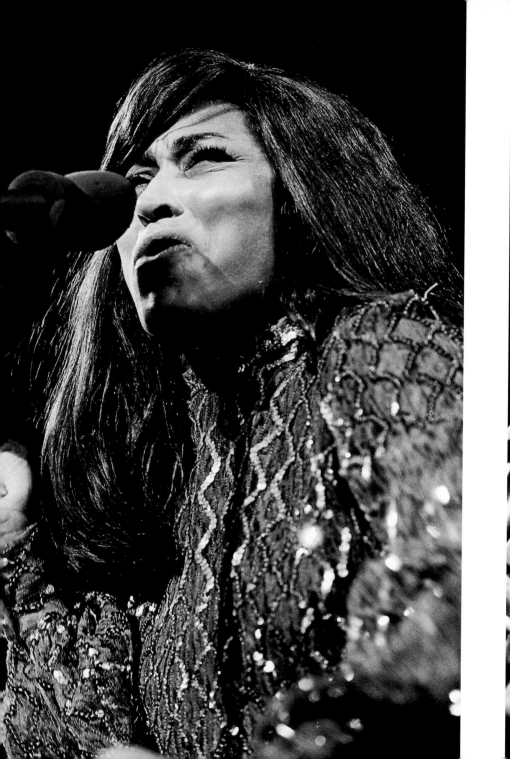
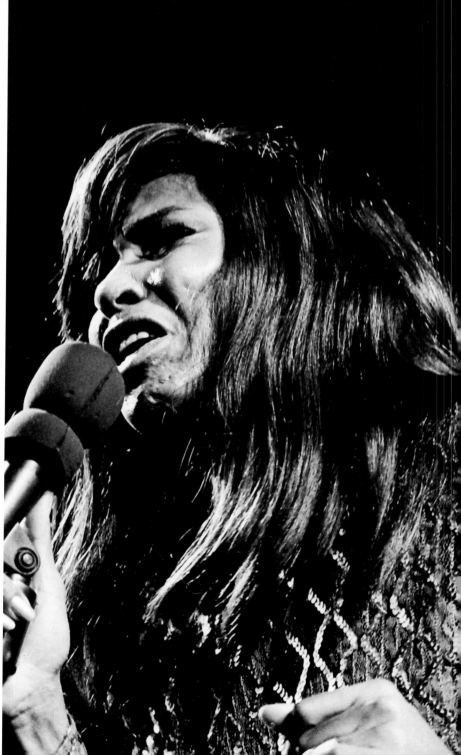

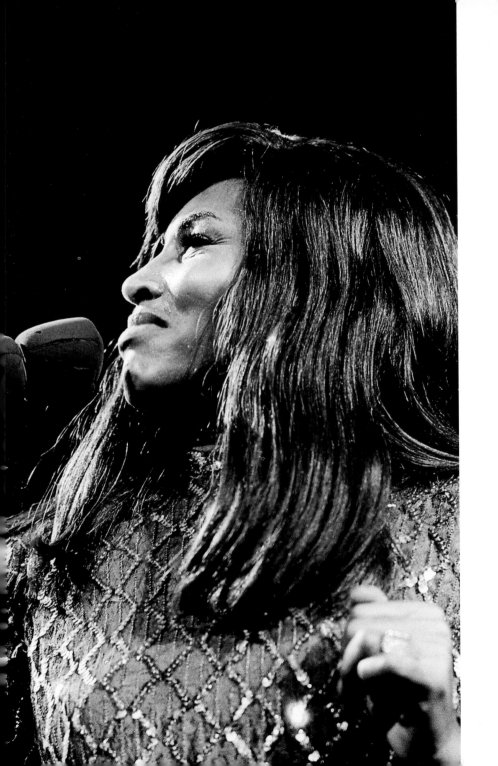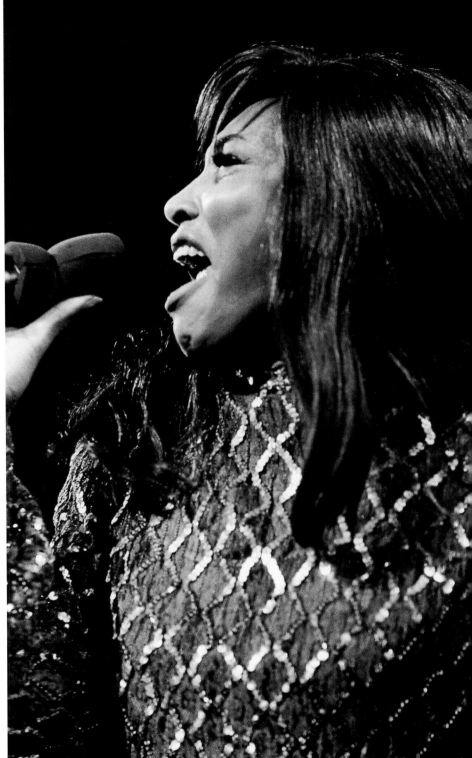

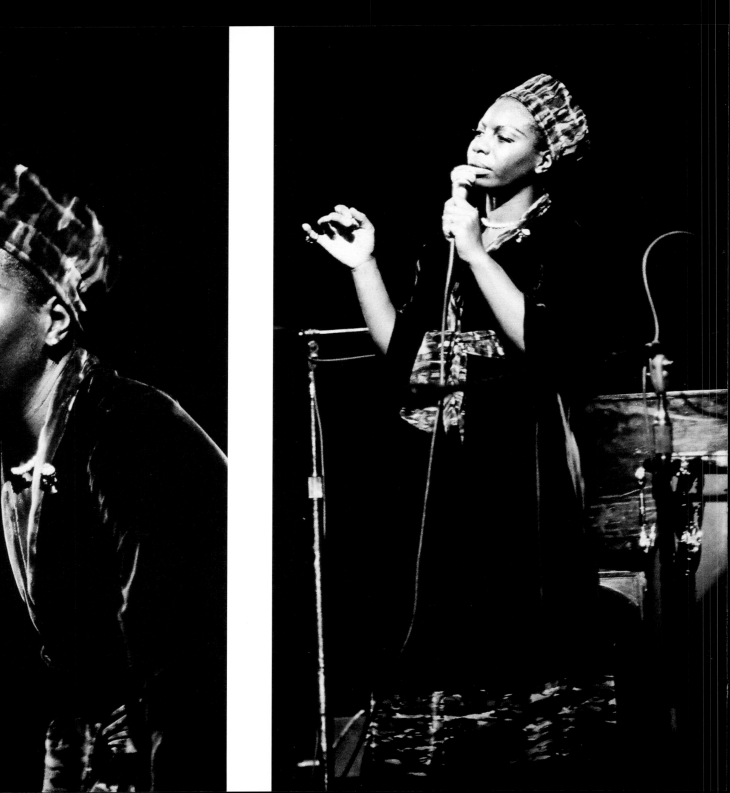

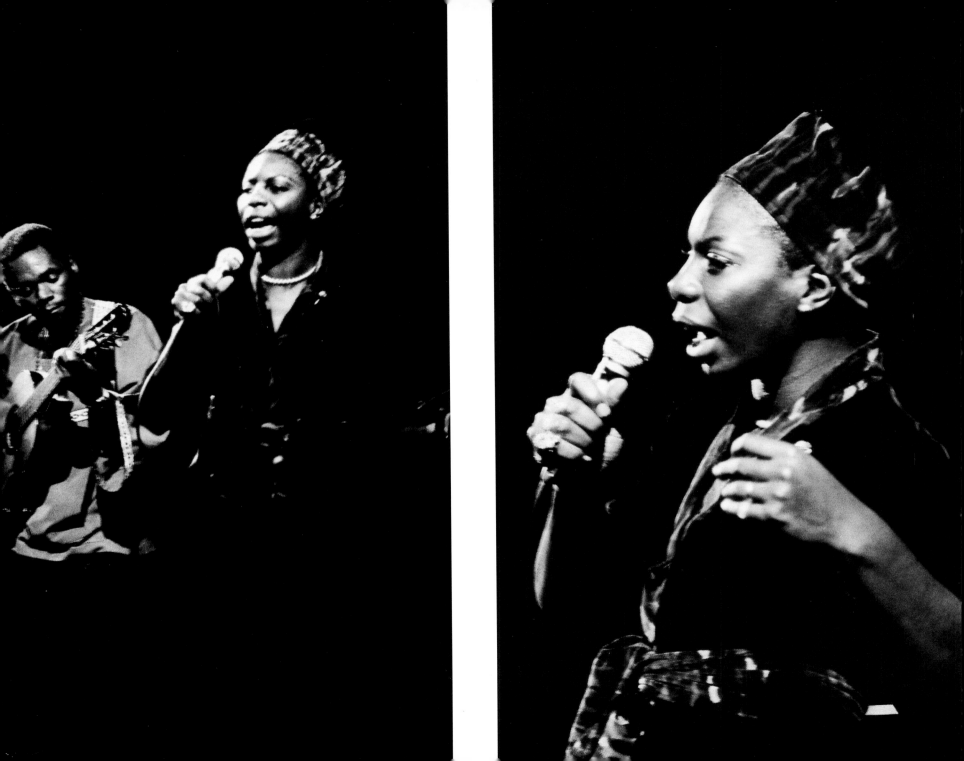

Trail of the Hippie

The young people who had tasted something very different in San Francisco didn't abandon their quest for a better life after the Summer of Love. They were soon to forge an entirely different path, one that became known as the Hippie Trail. Still in search of a life unfettered by material things, they found their way, first in a trickle and then in a veritable flood, to the mind-altering drugs and the more enlightened way of life of the East, specifically, Kathmandu in Nepal.

Nearly fifty years after Woodstock, that desire for a different kind of life continues to inspire and direct generations, creating a permanent and pervasive impact on American society. Though scarcely a classless society, and suffering from huge gaps in income and opportunity, America in the twenty-first century is moving in that direction, moving away, too, from ingrained racial prejudices.

Earth Day, April 22, 1970, Union Square Park, New York City

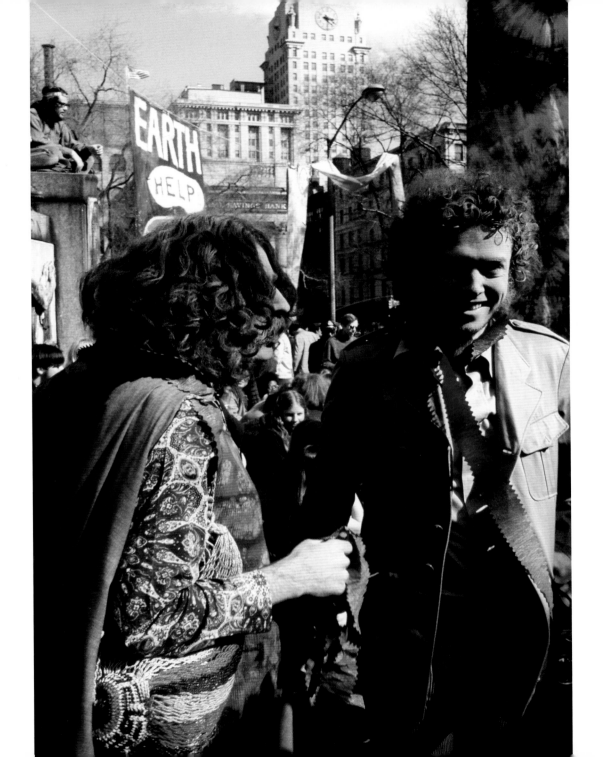

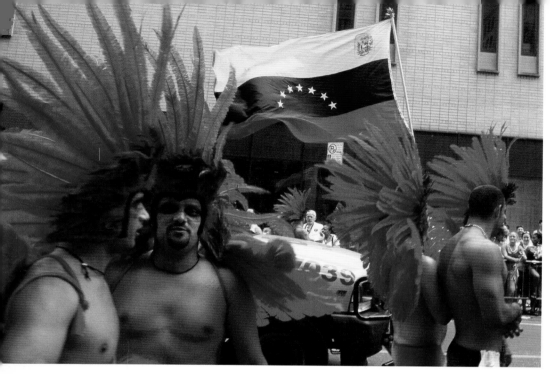

The great changes in society required changes in social attitudes as well as the law. Some of the most profound changes came about by uprooting laws that criminalized behavior. Acceptance of changes that affected gender inequality varied greatly across the country and the movement remains divisive to this day. Some states, mainly in the South, still have laws on their books that discriminate against homosexuals.

Gay Pride Parade, Fifth Avenue, New York City

Shortly before the Woodstock Festival, a storm that had been brewing for years over police harassment of homosexuals erupted at the Stonewall Inn in New York City's Greenwich Village. Preferring the term "gay" to the derogatory "queer," the newly energized movement gained momentum and two years later, on June 28, 1970, the first Gay Pride Parade was held in New York, in the same neighborhood. Today, the parade has grown to become one of the largest events in New York City. In 2016, President Obama designated the Stonewall to be a National Monument.

The search for more natural ways to live was accompanied by a growth in the use of marijuana, a more natural way to get high. At the time of Woodstock, growing, selling, or using marijuana was a criminal offense. Slowly, however, the country was beginning to accept the use of marijuana in easing pain.

In 1996, California became the first of twenty-three states to pass a medical marijuana law. In January 2016, New York state, which had had one of the most draconian laws against marijuana, joined the list of states allowing its use to ease pain where medically indicated. Recreational use of marijuana became legal in Washington, Colorado, and Oregon, with other states now considering similar laws.

Alarms about the environment were first sounded in 1962 when Rachel Carson published *Silent Spring*, warning of the deadly effects of pesticides on birdlife, in particular. Just eight years later, on April 22, 1970, the modern environmental movement can be said to have started with the first Earth Day celebration. Union Square Park in New York's Greenwich Village hosted one of the biggest events of the day. This multi-faceted movement brought together disparate elements seeking to try to heal some of the most abusive practices taking place on America's physical environment—and it worked.

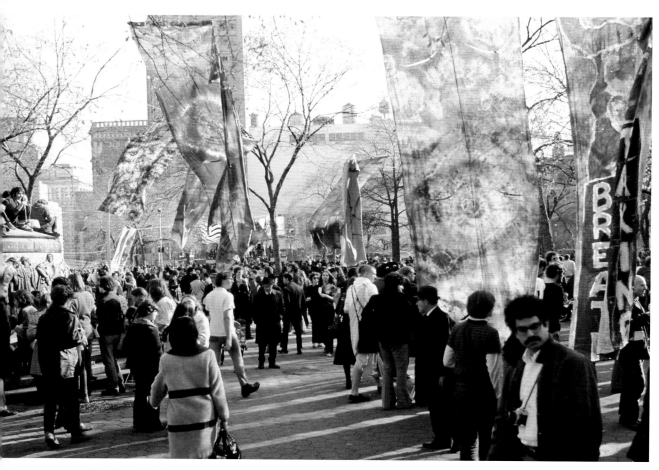

The well-organized event brought twenty million Americans out into the streets and parks to demonstrate for a healthier, more sustainable environment. Groups that had been fighting in isolation against toxic oil spills, factories that filled the air with toxic pollutants, and the overall loss of the wilderness to development unified their message under one movement.

The first Earth Day event, Union Square Park, New York City

At the same time, groups of people were forming communes in an effort to diminish their footprint on the land, to reduce their own levels of consumption, and to live lives more in tune with nature. One of the most successful and long-lasting of these was The Farm in Tennessee where, in 1971, Ina May and Steven Gaskin established a community of like-minded people. The Farm encouraged sharing, vegetarianism, and natural childbirth.

The Farm

Through the decades that followed, The Farm's Midwifery Center offered women an alternative to giving birth in a hospital setting. From prenatal care through labor coaching, as well as counseling in breastfeeding, Ina May and her team of midwives allowed women to experience childbirth in a calm, personal setting.

In 1972, the first issue of *Ms.* magazine was published. Founder and feminist Gloria Steinem saw that the women's movement for equal rights and equal pay needed its own voice, one directed by women. The feminist movement brought together women, and men, in a movement to extend rights that were reserved for men, as well as those areas where discrimination was practiced unofficially.

The Farm in Summertown, Tennessee

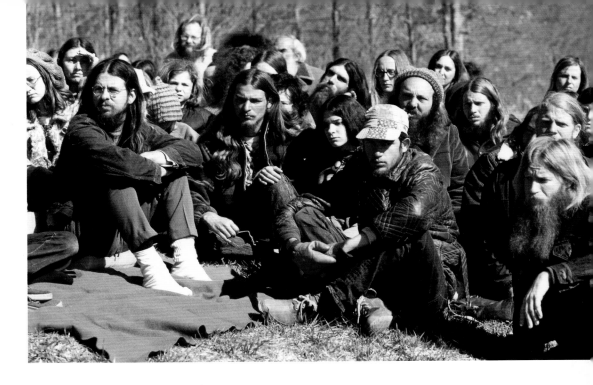

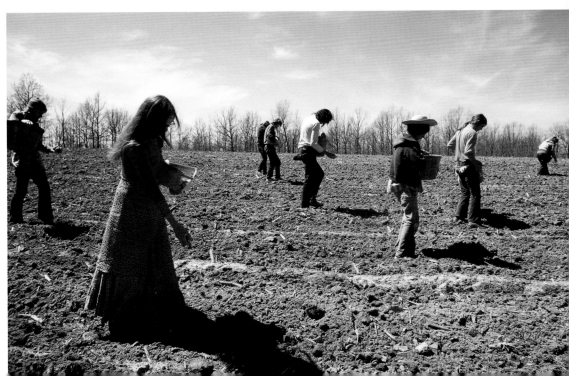

The search for enlightenment yielded various New Age events and movements that rippled out across the country and through the decades. Burning Man, an offshoot of a California event, began in 1990 in the Black Rock Desert of Nevada as a way to celebrate the participants' artistic creations and to live in a community where everyone shared resources. In spite of the remote location, the event has escalated from a handful of participants to more than 60,000.

The spirit of Burning Man spread around the globe with many countries staging their own events. AfrikaBurn, which began in 2007, now hosts nearly 10,000 people in the Karoo, a semi-desert region of South Africa. It embraces the volunteer spirit, the creation of art of all kinds, and stresses that when an event ends, every scrap of material that was used during its existence should be carefully disposed of. It is ironic that only countries with a thriving middle class population can support an event that asks them to shuck off the comforts of home for the chance to spend a few days or a week in the desert, in a non-cash economy. Just twenty years after the end of apartheid, South Africa has become one of those countries.

The Coachella Valley Music and Arts Festival began in 1999, in Indio, California, in a desert environment similar to Burning Man. Each year, Coachella features a line-up of top rock music acts.

The Rainbow Family gatherings are loosely organized annual events, always held on public lands, to celebrate and promote peace and enlightenment. Consciously the members consider themselves an informal group, seeking to avoid any sort of official presence and, in particular, refusing to pay fees to the National Parks Service for the use of public land. By doing so, they avoid charging a fee to the participants. They tend to keep the exact location of their events a closely held secret until the last possible moment, but most gatherings have taken place in the American West.

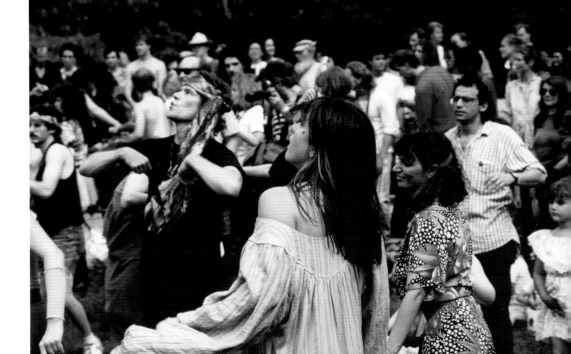

AfrikaBurn Festival, South Africa
© 2013 Tania Bester (top)

Rainbow Family in Central Park,
New York City (bottom)

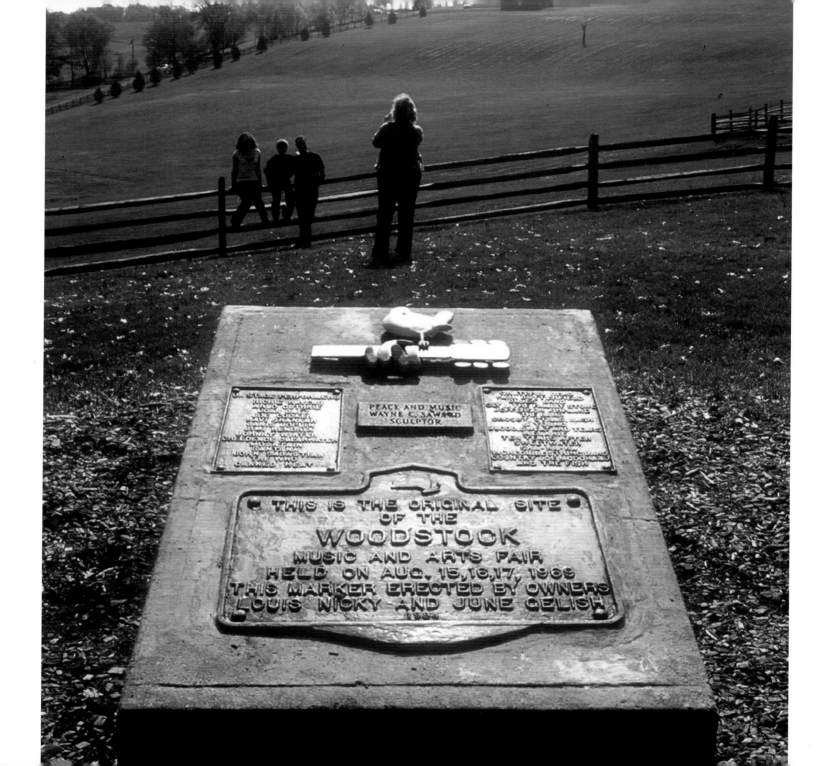

Lasting Impact of the Counterculture

Bethel Woods

For more than thirty years, the site of the Woodstock Festival, Max Yasgur's farm in Bethel, New York, remained largely the way it looked after the Festival, after the tons of trash were removed. Then, in 1996, cable television magnate Alan Gerry purchased the site of the original Woodstock Festival, as well as hundreds of acres around the site. In 2008, the Bethel Woods Center for the Arts opened with a museum dedicated to depicting all the events of the 1960s.

Amazingly, the museum succeeds in evoking the spirit and the facts of the entire era. Inventive use of multi-media displays, photos, text panels, and artifacts draw the visitor into the time period. Bethel Woods functions as a museum for young people and a living history to those who lived through the era. In its isolated locale, ninety miles from New York City in the Catskill Mountains, off the famous Route 17B that turned into a parking lot during the original festival, Bethel Woods has remained remarkably true to the spirit of the 1969 event.

It addresses the fun of the times as well as the tragedies, not shying away from depicting aspects of the Vietnam War such as the burning of draft cards, civil rights demonstrations, and the assassinations that rocked the nation and changed its history forever. But it also provides a bit of the experience of having been there through the use of recorded music, concert footage playing on video screens, and filmed interviews with some of the musicians who performed.

Down the road from the Bethel Woods Museum, on Route 17B, sits the Stray Cat Gallery, devoted to exhibits of local artists' work. Here, fans can view and buy Jason's Woodstock prints, as well as books about the era. Musicians perform at the Dancing Cat Saloon, across the road.

Few decades have left such a lasting impression as the Sixties. From the music,

the clothes, the graphics, and the hair, to the somber assassinations, marches, protests and arrests, the Sixties continue to resonate. The idealism has permeated through the culture, sending hundreds of thousands to lend their time, talents, and energy to the Peace Corps, Teach for America, Doctors Without Borders, and myriad helping charities. Communes still proliferate as participants try to reduce their footprint on the earth. Recycling, vegetarianism, and charitable giving of time and money do their best to pave a better path to a sustainable future.

While the museum at Bethel Woods is devoted to explaining and showing the Woodstock Festival and the Sixties generation—and was designed to blend into the bucolic countryside—several cities dotted around the country have their own halls devoted to the era. The Rock and Roll Hall of Fame in Cleveland, Ohio, celebrates the history of rock with artist interviews, listings of current musical happenings, and a celebrated Hall of Fame which annually nominates and inducts notable figures in the field. Nominees must have had at least twenty-five years of performing history to be given this honor.

Graceland stands apart in every way from the other monuments to rock history in Memphis and around the nation. It was the actual home of Elvis Presley; it is a museum devoted to just one person.

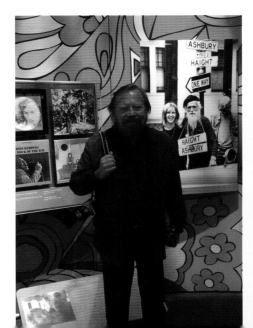

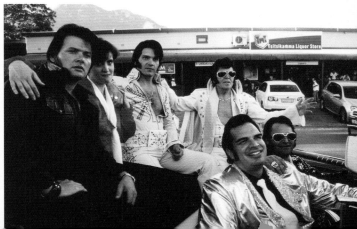

Elvis impersonators at Elvis Festival in Storms River, South Africa, in 2011, below. At left, Jason Lauré in the Bethel Woods Center for the Arts.

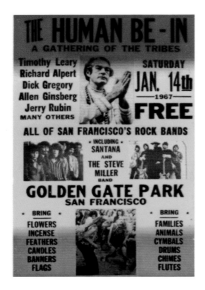

For those who were there as well as the millions for whom the Summer of Love is just a distant part of history, each year the Haight-Ashbury Street Fair celebrates and remembers the events of the summer of 1967. The festival centers on a poster competition, a nostalgic nod to the designs of the era.

The organizers hope the event helps to preserve the cultural and historical significance of the district, and the neighborhood's spirit of diversity, cooperation, and humanism.

Lasting Influence

Over the past fifty years, people of all ages have sought to replicate the generosity of spirit of the Sixties. More than 750,000 have found that special place at Esalen, a mind-and-body institute perched high above the Pacific Ocean in Big Sur, California. For a week or longer, they seek to experience an alternative way of life, out of the mainstream of conventional daily life.

While Esalen focuses on slowing down the mind and spirit in order to fully experience sensations, the ability to spread ideas grew at the speed of light, thanks to the creation of the Internet.

Haight Street, San Francisco

This revolutionary resource enabled like-minded folks to communicate and gather at a moment's notice. The Internet also made it possible for entrepreneurs and creators to bring their ideas and projects to market through crowdfunding websites. This democratic way of reaching a global market to gather funds has kept the Woodstock spirit alive.

For a taste of the counterculture on film, take a look at *Easy Rider*. This 1969 feature stars Peter Fonda and Dennis Hopper, who co-wrote the film with Terry Southern. It follows two motorcycle riders on a drugged-out tour of the American Southwest with the characters experiencing the hippie movement, the use of drugs, and communal living. It was the American equivalent of cinéma verité and introduced straight-laced America to the essence of the alternative hippie lifestyle.

The spirit, the mood, and the very essence of the Woodstock Festival was captured in a 1970 documentary, *Woodstock*. Directed by Michael Wadleigh, the film won an Oscar for best documentary feature and was also nominated for film editing. One of the three editors was the very young Martin Scorsese. The split-screen editing captured the excitement of the musical acts along with the communal life of the Festival. It is the next best thing to being there and has introduced generations of music lovers to the event.

Though nearly a half century has passed since the Summer of Love and the Woodstock Festival, these events remain enduring icons in popular lore. The music, the clothes, the hairstyles, and the mores all find their way back periodically. For older generations, they speak to a more carefree time. For younger generations, they offer hope that if enough people of goodwill band together, they can change the world.

© Ettagale Blauer

About the Authors

Jason Lauré followed his instincts as he photographed many of the landmark events of the 1960s, from Haight-Ashbury in San Francisco, to the Woodstock Festival and Fillmore East in New York. George Harrison's concert for Bangladesh on August 1, 1971, at Madison Square Garden, the first to raise funds for a major catastrophe, inspired him to travel to Bangladesh to photograph. His photos appeared in the *New York Times* and on the March 27, 1971, cover of *Newsweek*. His work over a six-month period led to his first book, *Joi Bangla: The Children of Bangladesh*.

A life-changing three-month trip across the Sahara led to a decades-long love of Africa. From that time, he has traveled around the continent, capturing cultures and political changes in many countries. Many books on Africa, co-authored with writer Ettagale Blauer, followed. A year spent in South Africa during apartheid and many stays afterward, led to his decision to make that fascinating and complicated nation his home. His memoir is called *Africatrek*.

After struggling with mood swings for nearly a decade, he was diagnosed with manic-depression and began taking lithium under the supervision of Dr. Ronald Fieve, the leading researcher in New York City. He credits that drug with stabilizing his moods while allowing his creativity to flow. He divides his time between New York City, where his daughter Mirella lives, and Cape Town, South Africa, where he lives with his wife, Jade.

Ettagale Blauer is the co-author with Jason Lauré of more than thirty books on foreign countries, including South Africa, Botswana, Morocco, and Madagascar. Their book on the birth of Bangladesh, *Joi Bangla*, was nominated for a National Book Award. She is a versatile writer and is the author of *African Elegance* and *Contemporary American Jewelry Design*.

She has written feature stories on all aspects of the diamond industry, cutting, mining, trends, and auctions. Her experiences in visiting diamond and gold mines deep within the earth gave her a unique perspective on the jewelry industry. Writing for the leading magazine in the field, she has created unique databases of the world's most important diamonds: colored gemstone record-setters as well as the most important jewelry estates sold at auction.

Ms. Blauer earned a Bachelor of Arts degree from Hunter College in New York City. She has received numerous awards for her writing, including the 1998 Benne Award from the American Jewelry Design Council. She resides in New York City, her hometown, where she writes a monthly column on jewelry sold at auction.

Jason Lauré's Woodstock exhibits and major book credits

Vogue magazine, "Sleeping Youth" photo compared to Gauguin, 1969

Woodstock, Public Theatre, New York City, January 1970 and 40th anniversary essay celebrating original Woodstock photographers in 2009

Being Without Clothes, MIT, Hayden Gallery, Cambridge, November 1970

Will we ever get over the Sixties? *Newsweek* cover, September 5, 1988

Woodstock Remembered, 20th anniversary exhibition, Center for Photography at Woodstock, New York, summer, 1989

Woodstock exhibit, Wetlands, New York City, August 1989

Making Sense of the Sixties, television show

Sotheby's auction of black/white **Woodstock Portfolio** sold to Hard Rock Café, 1994

Mothers and Daughters exhibit, Burden Gallery, Aperture Foundation, New York, 1987

"The Mother of all Festivals," **Woodstock** article, *Playboy*, South Africa edition – 1994

Times Herald commemorative newspaper illustrated throughout with color poster, 1994

The World and I, "Memory of a Free Festival, Woodstock 30 Years Later," 1999

Tommy Hilfiger stores in Hollywood and New York, **Woodstock** exhibit in b/w 2004–2005

The Sixties: Summer of Love to Woodstock, 3RD i GALLERY, Cape Town 2007

Bethel Woods Museum, New York, on original site of Woodstock Festival; images permanent exhibition, opened 2009

Woodstock, Three Days that Rocked the World, Sterling Publishing, 2009

Woodstock, Genesis Publishing, 2009

Rhino Records, Commemorative **Woodstock** CDs and book, 2009

Santa Monica Auctions: two lots of seventeen vintage **Woodstock** prints featuring rock stars and communal life, sold October 2009

RollingStone.com – rock stars from **Woodstock Festival**, 2009

Santana: **The Woodstock Experience** – CD cover – Sony Music, 2009

Bethel Woods Museum, New York, one-man **Woodstock** exhibition, March-May 2012

Bonham's Entertainment Memorabilia auction, **Woodstock** portfolio – June 24, 2012

Bethel Woods Museum, New York, The Performers of the **Woodstock** Festival, 2016

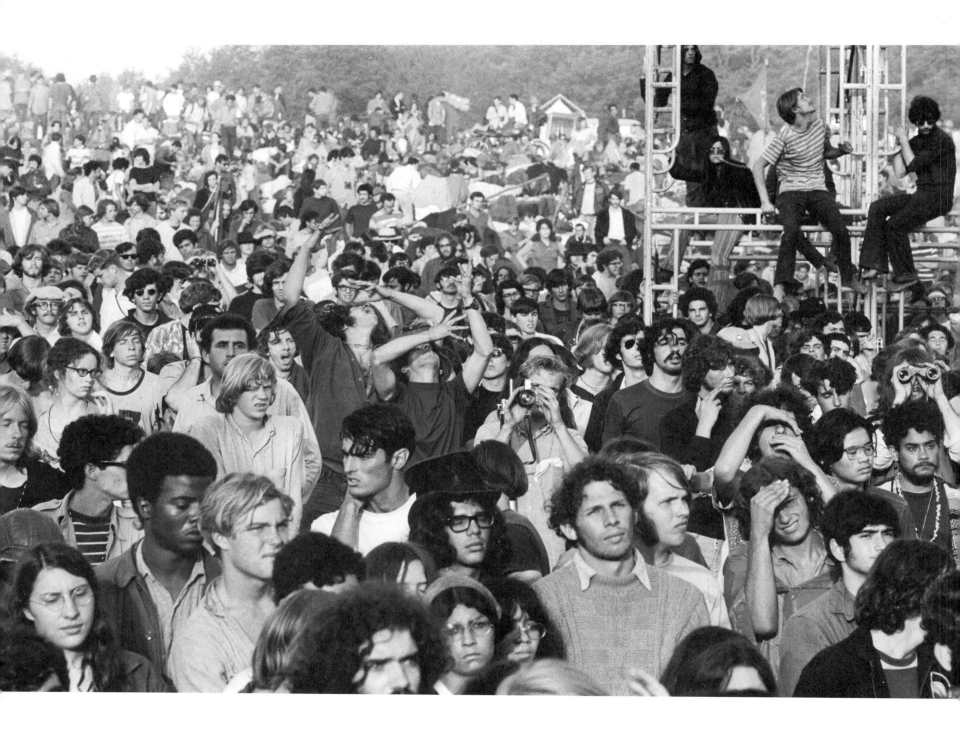